Learn to Draw

BOATS

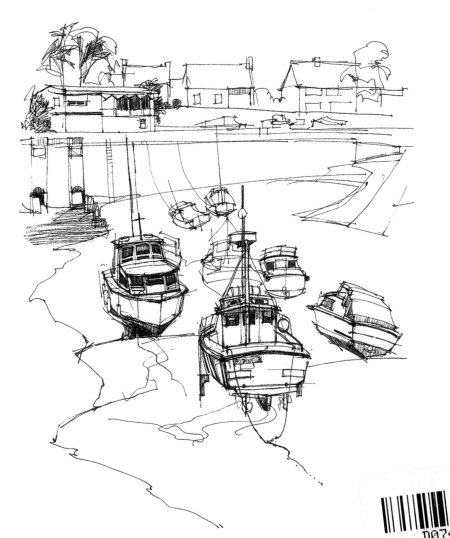

Moira Huntly

HarperCollinsPublishers

First published in 1998
by HarperCollins Publishers
London

© HarperCollins Publishers 1998

Produced by Kingfisher Design, London
Editor: Diana Craig
Art Director: Pedro Prá-Lopez
Designer: Frances Prá-Lopez

Contributing artists:
Ray Evans *(pages 12, 43, 48 top, 57 bottom, 60 bottom)*
Gordon Hales *(pages 6 bottom, 11 bottom, 39 top, 40, 41 bottom)*
Neil Meacher *(pages 13, 29 top, 44/45 main drawings, 60/61 top)*

The painting of Belfast Harbour on page 63 is reproduced
by kind permission of CWS Ltd.

A catalogue record for this book is available from the British Library

ISBN 0 00 413305 6

Manufactured in China

CONTENTS

Introduction

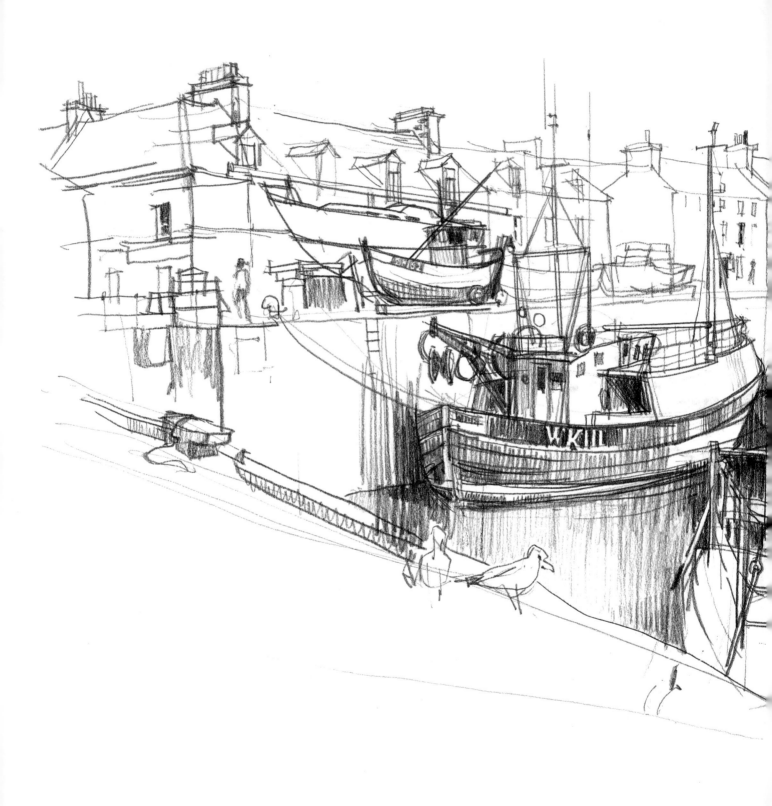

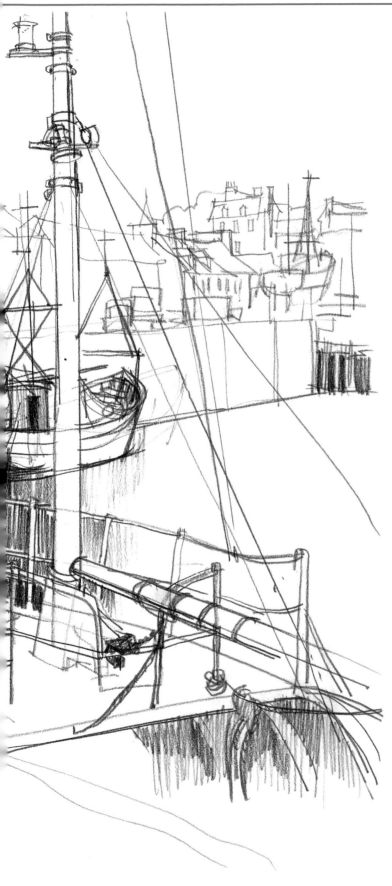

Marine subjects have inspired artists for hundreds of years, and they continue to do so today. Although many maritime nations have dwindling fleets of fishing boats, there are still plenty of activities in harbours and around the coastline to attract the artist. Many times whilst sketching by a waterfront – as I did at this harbour in Wick, northeast Scotland, opposite – I have had people look over my shoulder and say, 'How I wish I could draw boats, but they are much too difficult.' In this book I aim to simplify the task so that drawing this fascinating subject is not beyond the scope of beginners. Among its pages you will be introduced to basic shapes and construction of boats, the characteristics of different types of vessel, perspective and details, as well as many other aspects.

Many a well-painted landscape has been spoiled by the inclusion of a badly drawn boat and I hope that the guidance offered throughout this book will give you enough confidence to include boats in your drawings, and to enable you to make a drawing that will satisfy even the seasoned eye of a seaman.

Moira Huntly

Tools and Equipment

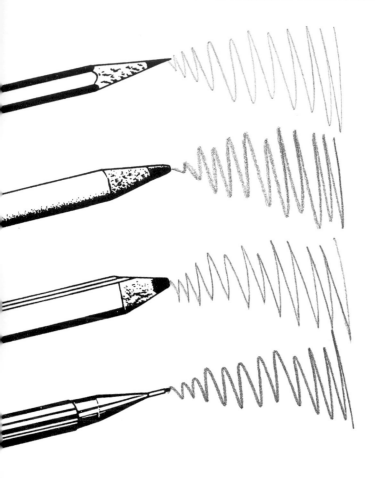

Pencils

Ordinary pencils are excellent drawing tools for the beginner, being easily obtainable, convenient to use, and versatile. They are ideal for quick sketches, making 'roughs' for compositions, or for highly finished drawings. They produce a range of marks, from fine detail to broad areas of tone, depending on the thickness of the lead.

Pencils are graded from extremely hard, 9H, down to 2H and H. The soft grades start at B, then 2B, progressing to the softest at 9B. HB, in the middle of the range, is medium-hard. Hard pencils produce fine, light grey lines, and soft pencils make thicker, black lines. Coloured pencils are also available in a large range of shades. Some types are water-soluble, so that if you moisten the marks you have made they dissolve slightly to produce a paint-like effect. There are also clutch and propelling pencils which have a variety of leads, and do not require sharpening. Softer pencils wear down very quickly, however, so remember always to carry a knife or pencil sharpener with you.

Explore the potential of as many different pencils as possible, and the effects they create. Don't be afraid to smudge or gently erase areas, or to combine soft pencils with hard.

A very soft 6B pencil on smooth, white writing paper was used for this sketch, 'Low Water, by Hungerford Bridge', by Gordon Hales. With a minimum of detail, it captures the feeling of light and shade, and activity.

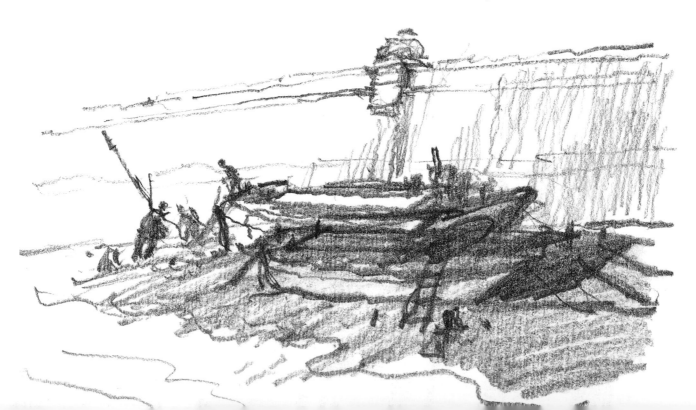

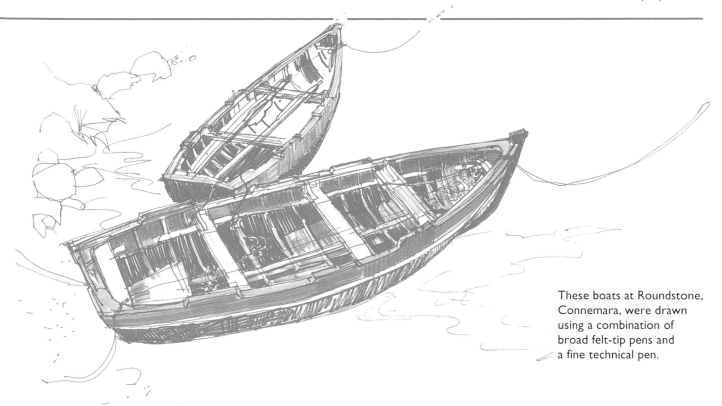

These boats at Roundstone, Connemara, were drawn using a combination of broad felt-tip pens and a fine technical pen.

Pens

There is a huge range of pens to choose from, which can make almost every type of mark, from fine lines to broad bands of tone.

Dip pens are used with black or coloured inks. They can take a range of flexible nibs, which can create variations in the thickness of line depending on the amount of pressure applied.

Ballpoint and **fountain pens** are easy to use, but the ink is not always permanent or waterproof.

Fibre- and **felt-tip pens** may or may not be permanent or waterproof. Their variety of width and colour make them invaluable drawing tools.

Technical pens give a line of uniform thickness, and are waterproof.

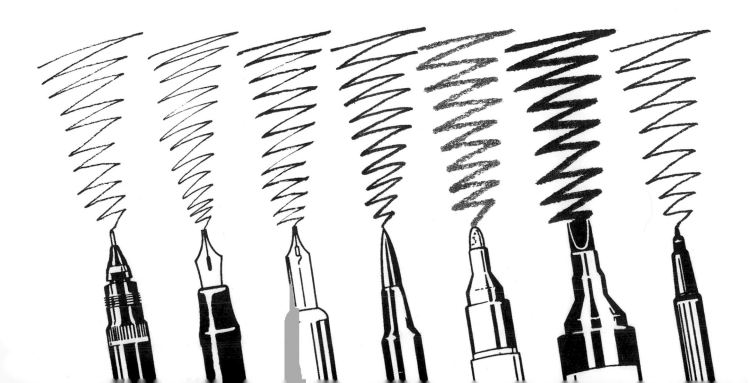

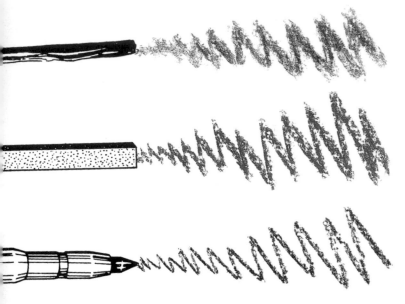

Charcoal and pastel

These materials have a soft texture, and are ideal for producing broad, bold marks.

Charcoal is available in sticks of varying thickness. It is the softest of the drawing media, and is good for tonal drawings. It does not generally offer the precision of pencils or pens, so if you want to include highlights in your drawing, these are best lifted out with a putty eraser towards the end of the work. Because charcoal can easily be brushed off by mistake with a careless sleeve, stabilize your drawing by spraying it with fixative – preferably an odourless variety.

Charcoal and **conté pencils** can be sharpened and give a strong yet sensitive line, ideal for adding details such as rigging to a drawing.

This sketch of an estuary was produced in charcoal. Some areas were smudged with a finger to soften them, and a putty eraser was used to achieve the strip of light on the water.

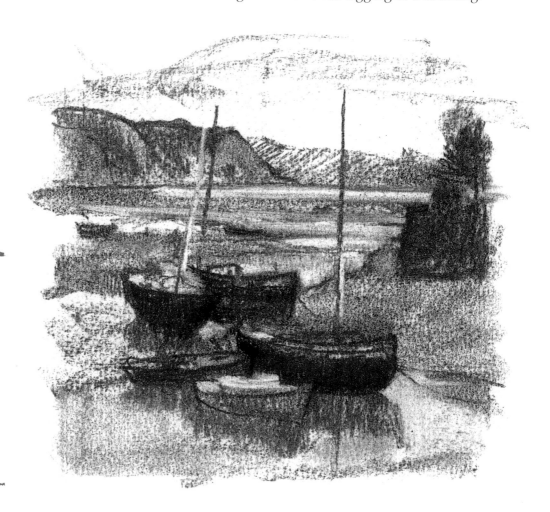

Artist's Tip

When using a fixative spray, first test the pressure by spraying onto a spare piece of paper. Oil pastel does not need fixing, but interleave your sketches with greaseproof paper to prevent pastel from one drawing off-setting onto another.

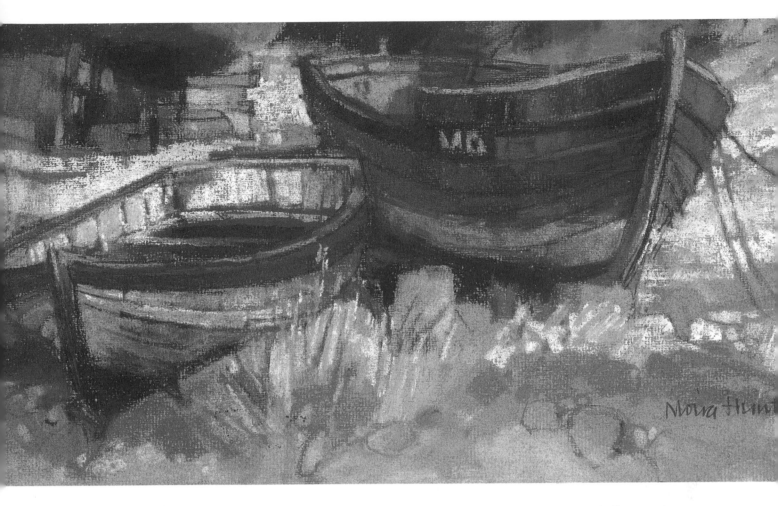

Pastels

Pastels are an opaque medium with a velvety bloom. They are available as sticks or pencils, a hardened form that can be sharpened. Both types offer a wide range of colours. Soft pastel sticks are graded from 0-6 or 8 according to their depth of tone. Pastels can be used as drawing tools and in the same way as paint, and so provide a bridge between painting and drawing. Applying their pure pigment to a surface gives a spontaneous immediacy to a drawing, but you should ideally use a surface that has a 'tooth', or texture, that will hold the particles of pigment.

Oil pastels are quite different from pure, soft pastel. They are soft and waxy and can provide both an oil-paint and pastel effect. They are useful for quick, on-the-spot, broad sketches.

This drawing in soft pastel of two boats at Abereiddy in Wales is on toned Ingres paper. It illustrates how pastel can be both a drawing and a 'painting' medium.

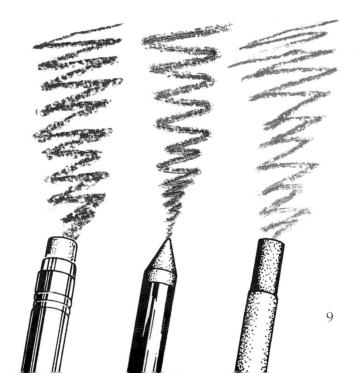

Brushes and wet media

Brushes can be round or chisel-shaped. The best but most expensive brushes are made of sable. They hold colour well, come to a fine point and last for years, so invest in one if you can. Alternatively you can use less expensive ox- or squirrel-hair brushes. The smallest brush size is 000 progressing up to 12. To begin with, choose three brushes: a medium-sized round or chisel 5 or 6, a small brush 0 or 1 for details and fine lines, and a wash brush for covering large areas and soft blending.

Watercolour can be obtained in tubes or pans, and is ideal for quick colour sketches or for adding washes to a drawing. Colours can be made lighter by using more water, but remember that watercolour will appear paler when it has dried. The transparency of colour

3　　　　　　　**5**

4　　　　　　　**6**

3 For an even layer of strong watercolour, add darker washes to a light wash while still wet.

4 To prevent colours 'bleeding' together, allow the first layer to dry before you add the next.

5 For a soft blurry effect, apply watercolour to paper that has been slightly dampened.

6 Ink or concentrated watercolour on damp paper will 'flare' and spread into the wash.

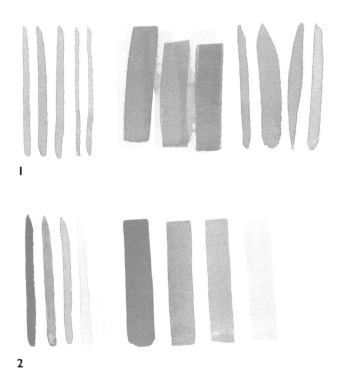

I

2

I These marks were made with *(from left to right)* a small round No 2 brush, a ⅜in flat chisel brush, and a large round No 12 brush.

2 Watercolour tone can be made progressively lighter by adding more water, as shown by these strokes using different dilutions.

washes is the main attraction of this fluid, spontaneous medium; however, too many superimposed washes will muddy the effect. The appearance of a wash is also affected by the *support* (the drawing surface). A flat, even wash can be achieved on a smooth paper, whereas pigment will settle unevenly on a rough-textured paper, producing a quality that is good for sparkle effects, such as sun on water.

Gouache is an opaque watercolour sometimes referred to as 'body colour'. It is sold in tubes. A versatile medium, it has different qualities depending on the amount of water added – the less water you use the more opaque the paint will be. Unlike watercolour which is transparent, lighter shades of gouache can be painted over darker ones. It is particularly impressive on dark-toned and coloured papers.

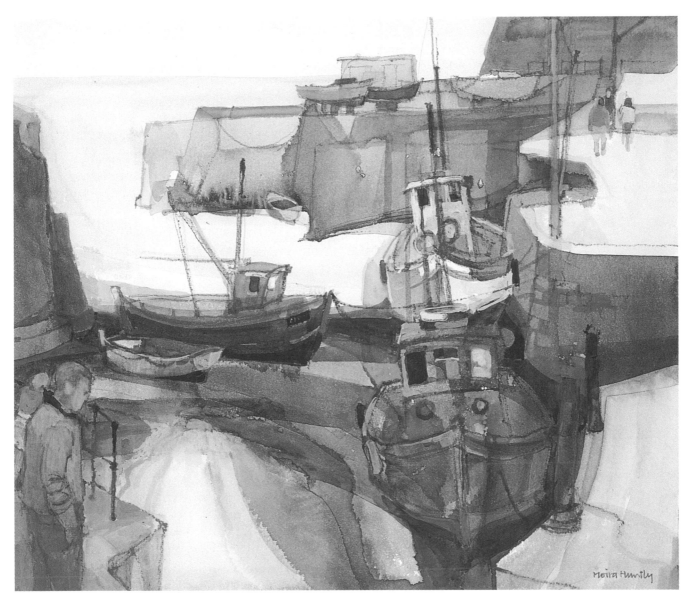

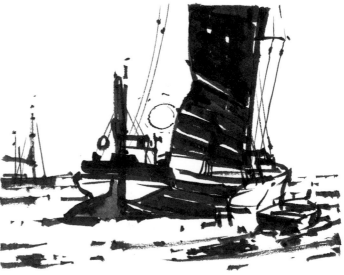

In this watercolour entitled 'Low Water' *(above)*, a wash brush was used for large areas, medium-sized brushes (Nos 5 and 8) for the dark washes, and finally, line drawing was superimposed using a small (No 1) brush. There was no preliminary pencil drawing.

For this lively sketch *(right)*, Gordon Hales used brush and ink on smooth mountboard. A fully loaded brush produced the solid blacks, but as the brush ran dry a dragged effect was achieved in places.

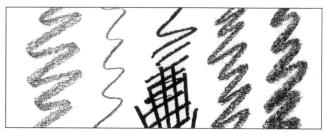

Newsprint is very inexpensive, which makes it good for practising and rough sketching.

Tracing paper is semi transparent, so that you can lay it over other images and trace them.

Stationery paper, usually available in standard sizes, has a smooth surface which works well with pen.

Cartridge paper has a slightly textured surface, and is one of the most versatile surfaces.

Surfaces to draw on

There are many papers to choose from, in a large variety of surface textures and colours. You can practise your first attempts on cheap paper such as newsprint or brown wrapping paper (for charcoal) but the most versatile and commonly used drawing surface is cartridge paper. Pin or clip your paper to a drawing board, or use a sketchpad.

Cartridge paper is available in different weights. It has a slightly textured surface suitable for pencil, ink, watercolour and charcoal.

Watercolour paper is available in a variety of weights, such as $190gm^2/90lb$, $300gm^2/140lb$ and $425gm^2/200lb$, and comes in a range of surface textures. *Hot-pressed* (HP) is smooth and suitable for line and wash. *Cold-pressed* (NOT) is a good, all-round surface for large washes and dry-brush effects. *Rough*, as the name implies, is a heavily grained surface, suitable for textures and impressionistic work.

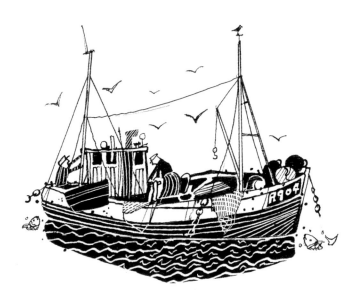

In Ray Evans' drawing of a Norwegian fishing boat, the artist used black Indian ink on white scraperboard. Fine white lines were achieved by using a scalpel to scrape away the ink.

Pastel and Ingres paper, with textured surfaces and in many colours, is ideal for pastel, charcoal and conté.

Watercolour paper is absorbent, and can have a rough or smooth surface. It is ideal for wet media.

Bristol board has a smooth surface which makes it highly suitable for drawings in pen and ink.

Layout paper is a semi-opaque, lightweight paper which is suitable for both pen and pencil.

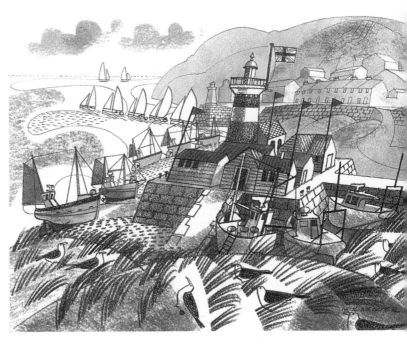

Neil Meacher used 300gm²/140lb watercolour paper for this drawing of boats in watercolour and soft graphite pencil. This rough surface is a favourite with the artist because it offers an opportunity for instant textures, particularly when the pencil is used across the paper, almost flat to the surface.

Pastel and **Ingres papers** or **boards** are suitable for pastel, chalk, charcoal, pencil, and will be light-fast. Boards and thicker papers can also be used for watercolour and gouache.

Sugar paper and **cover paper** are cheaper alternatives to pastel and Ingres papers, but may not be light-fast.

Scraperboard has a smooth, china clay surface, coated in black or white on which lines and dots can be scraped. On black scraperboard, you will be drawing 'in reverse', creating darker areas and outlines by scraping away the highlights.

Many of the papers mentioned above are obtainable in pad form, which is ideal to take out on a sketching excursion. If you are using individual sheets, you will also need a board to rest them on, and spring clips to keep the sheets attached to the board while you are working. These clips can also be useful for securing the pages of a sketchbook in breezy weather.

Choosing a Medium

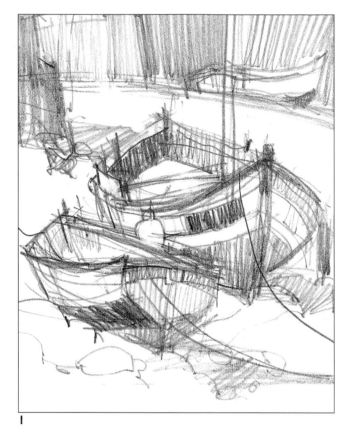

1

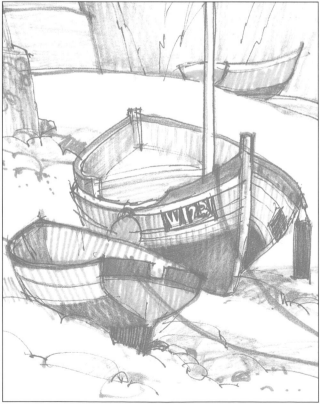

2

The materials you choose will vary depending on your intentions and preferences. You may have already developed your own methods of applying tone, colour and line, but it is good to experiment occasionally and try out new techniques. The type of support you use will play a vital role in the general effect, and the various surfaces available have been mentioned on pages 12-13.

The drawings on these two pages give an idea of the different effects that can be achieved with combinations of particular media and supports. Other combinations can give interesting results, too, such as watercolour and black and white conté pencil on toned paper; or ink, gouache and white conté on toned paper, or ink, gouache and watercolour on toned paper. Try felt-tips, markers and pastel pencils on cartridge paper or watercolour pencils and wash on watercolour paper. The permutations are many. In a pencil drawing, try using a combination of HB, 2B and 6B pencils: keep the HB sharpened for details and fine lines, use the 2B and 6B on their sides to create soft tones, and apply strong pressure to the 6B to produce intense black.

For capturing atmosphere, soft media such as pastel, charcoal or watercolour work well, while for fine, line detail and precise drawing, pens or sharp pencils are a good choice. Working with black and white on a mid-toned paper can help to create *chiaroscuro* effects (dramatic contrasts in light and shade).

1 HB pencil on writing paper
2 Felt-tips and technical pen on 60lb cartridge paper
3 Soft pastel on Canson pastel paper
4 Charcoal and charcoal pencil on thin cartridge paper

5 Dip pen and black Indian ink on smooth card
6 Watercolour and watercolour pencils on 300gm²/140lb NOT watercolour paper

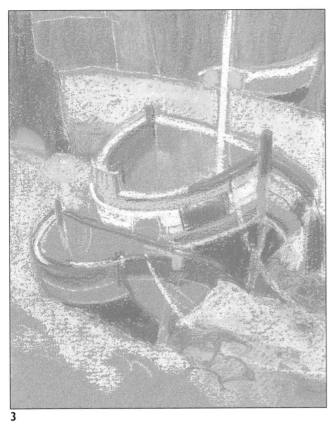

3

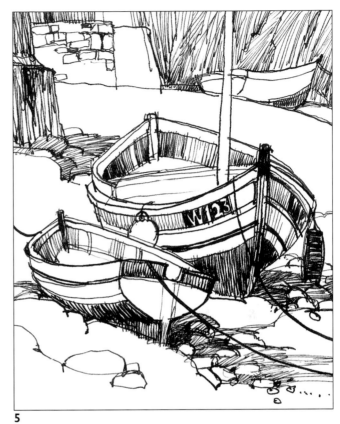

5

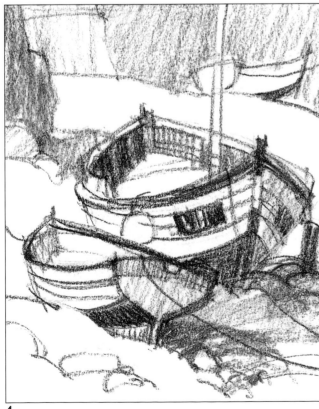

4

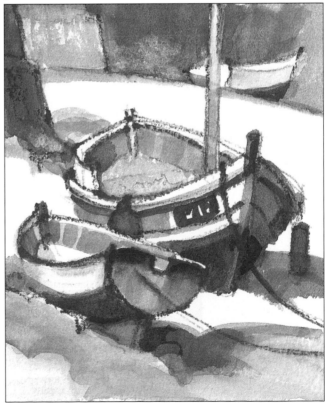

6

Naming the Parts

Art materials and surfaces to paint on have already been dealt with in some detail. Before going any further, I would now like to introduce you to some terminology, which you should find useful. Many of the marine terms listed below will be familiar and obvious to you, but the list is not exhaustive.

Aft Area towards the rear of a ship
Beam Widest measurement of a vessel
Boom Pole along the bottom of a sail
Bow Front end of a boat/ship
Bowsprit Pole at the bow of some ships
Capstan Machine used to haul up the anchor and wind ropes
Clinker-built A method of building a wooden boat with overlapping planks
Fore Area towards the front of a ship
Gunwales Upper edge of a boat's side (also known as gunnels)
Hull Main part of a boat (the shell)
Keel Bottom part of the hull (the 'spine' of the ship)
Mast Central pole for sails
Mizzen mast Mast nearest to the stern
Port Left side (when facing forward)
Rowlock Wooden or metal loop that holds the oar and allows it to pivot
Rudder Steering device
Spinnaker Large sail at front of racing yachts
Starboard Right side (when facing forward)
Stern Back end of a boat/ship
Tiller Handle to control rudder
Transom Horizontal beams across the stern section

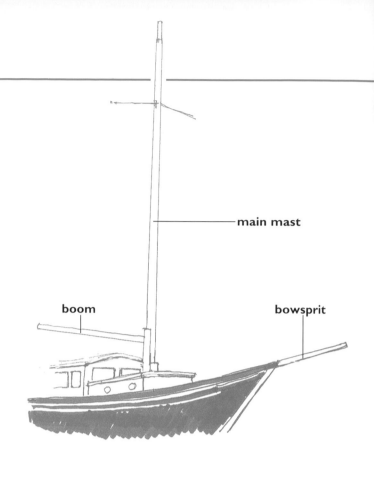

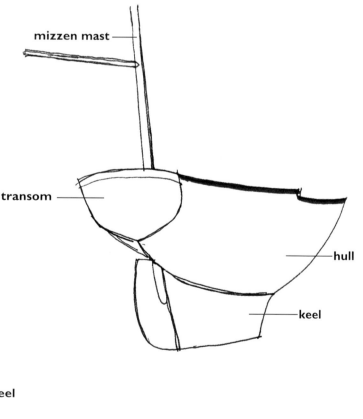

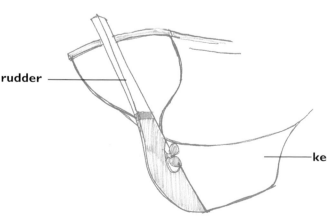

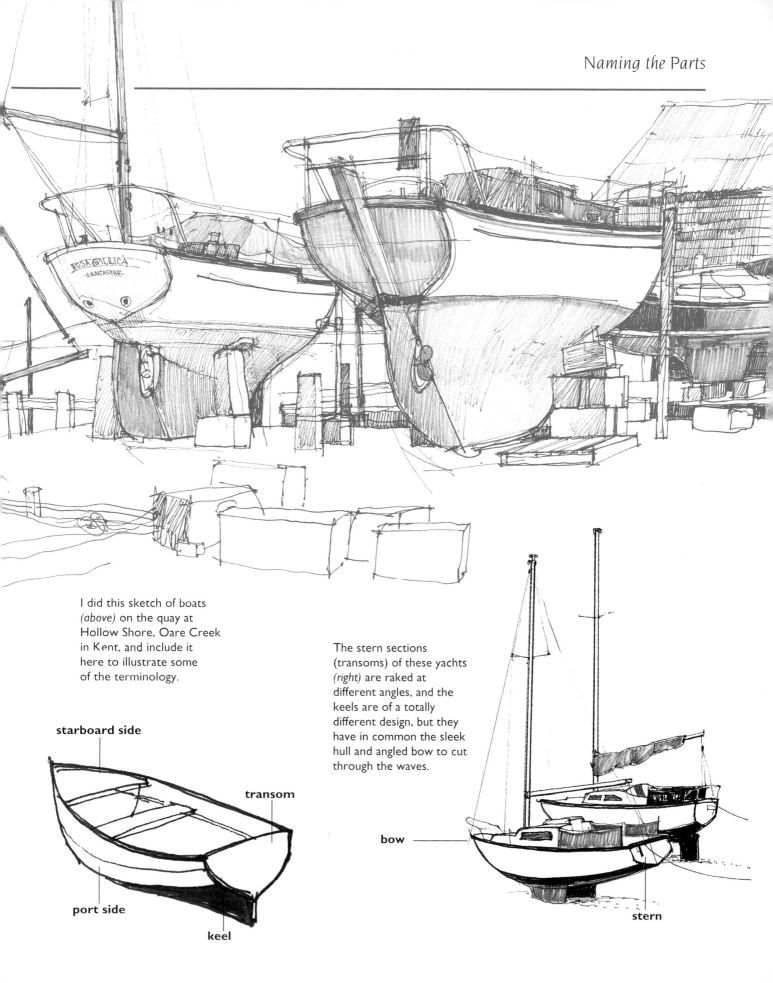

I did this sketch of boats *(above)* on the quay at Hollow Shore, Oare Creek in Kent, and include it here to illustrate some of the terminology.

The stern sections (transoms) of these yachts *(right)* are raked at different angles, and the keels are of a totally different design, but they have in common the sleek hull and angled bow to cut through the waves.

starboard side

transom

port side

keel

bow

stern

Looking at Boat Shapes

Learning to draw boats, like any other subject, requires constant practice and keen observation. All the work you put in becomes worthwhile, though, when you produce a drawing of a boat that looks convincingly seaworthy.

Harbours at low water are ideal for observing the structure of boats. Here you can follow the line of the keel joining bow to stern, and make drawings of a boat from different viewpoints.

Small Boats

Small boats come in all shapes and sizes and are probably the best kind of craft on which to try out your sketching skills when you are starting out, since they have the least complicated forms.

Older traditional wooden boats are usually more interesting to draw than the glass fibre or reinforced plastic boats of today, which are often less attractive to the artist. One traditional way of building small wooden boats is by the 'clinker' method (see page 16), whereby each external plank of wood is attached horizontally to the boat's framework of ribs with copper nails. Each plank overlaps downwards over the next one, making for a strong hull, and a more aesthetically pleasing effect for the artist.

This side view of a simple boat shape *(above)* shows its gently curved outline. Notice how the bow rises higher than the stern, and how the stern cuts under more than the bow.

This flat-bottomed dinghy *(above)* has a wide shallow stern and a squared-off bow.

1 & 2 In the two stages of this drawing of a clinker-built rowing boat *(above* and *right)*, with overlapping planks attached to the ribs, the framework of ribs can easily be seen.

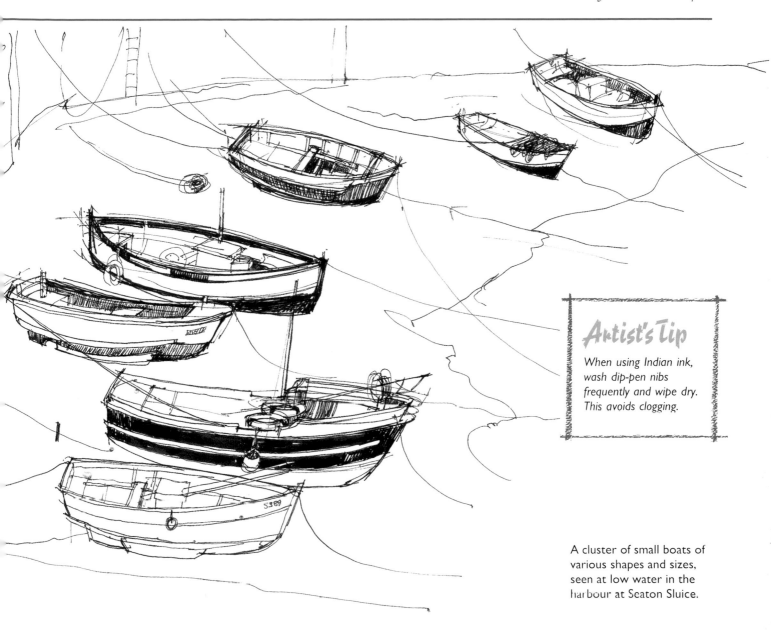

Artist's Tip

When using Indian ink, wash dip-pen nibs frequently and wipe dry. This avoids clogging.

A cluster of small boats of various shapes and sizes, seen at low water in the harbour at Seaton Sluice.

Individual character

In the drawing of the harbour at Seaton Sluice in Northumberland, shown above, each small boat has its own individual character. Some are wider across the beam than others, bow shapes and angles vary, and one boat is 'double-ended' or, in other words, it is pointed at both bow and stern. It was not until after I had completed the drawing and stood back to look at it that I realized how varied the boats were.

I used Indian ink to draw this boat *(right)*, seen on the Norfolk coast.

Fishing boats

For years fishing boats have provided artists with picturesque subject matter. The images are endless – masts against architectural harbour features, a jumble of different shapes and sizes of boat unloading at a quayside, beached fishing boats against the backdrop of a changing sky. Our harbours are less busy today, but there is always some activity to record.

The design of fishing boats is often traditional to a specific region, as are their registration numbers, which give a clue as to the port of origin. Here I have illustrated a few of these different designs. The smallest and simplest to draw is the boat with the for'ard cabin which I sketched on the coast of northeast England.

I started by drawing the hull, thinking of it as an oblong box pointed at one end. The sides were drawn with a lazy sweep of the pencil, gently curving the lines to meet at the bow. Note that the bow is higher than the stern, and angled more acutely. The cabin is also angled, as if leaning forward into the wind. The windows are first indicated as simple rectangles, then the subtlety of their curved corners is developed, and the final details added.

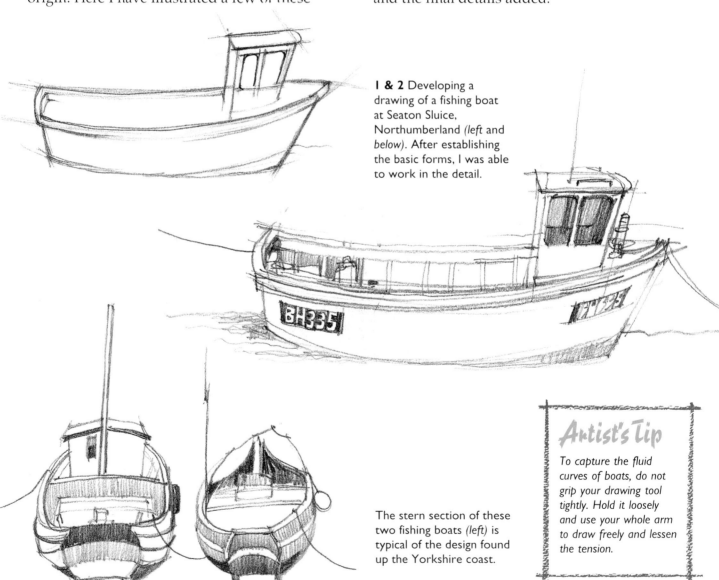

1 & 2 Developing a drawing of a fishing boat at Seaton Sluice, Northumberland *(left and below)*. After establishing the basic forms, I was able to work in the detail.

The stern section of these two fishing boats *(left)* is typical of the design found up the Yorkshire coast.

Artist's Tip

To capture the fluid curves of boats, do not grip your drawing tool tightly. Hold it loosely and use your whole arm to draw freely and lessen the tension.

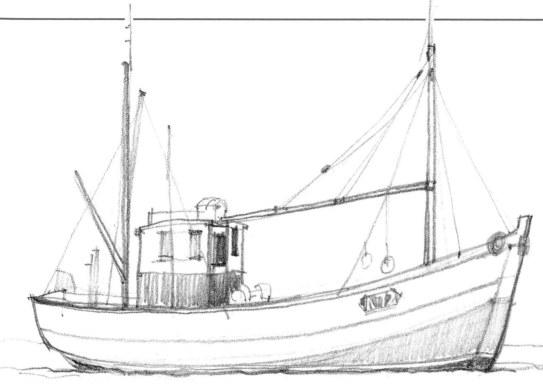

This two-masted fishing boat at Saundersfoot in south Wales *(left)* has a high bow and the cabin placed aft.

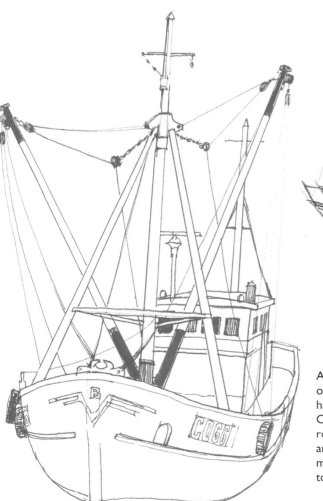

This fishing boat from Brixham, Devon *(above)* has elegant lines, a sharply angled stern and an upright six-sided for'ard cabin.

A large fishing boat typical of the type seen in the harbour at Falmouth, Cornwall *(left)*, with a rounded bow, the cabin aft, and a complicated series of masts, blocks and tackle to draw.

Sailing boats

Many of us have a nostalgia for sailing ships, especially those of yesteryear – the clippers, barques, schooners, sloops and sailing barges. If you are lucky enough to find them today, these tall ships with their long, sleek hulls and towering masts are always an attractive spectacle. Billowing sail against vertical masts have provided a pictorial pattern that has inspired many artists over the years.

The natural elegance of ships that sail still applies to the modern yachts of today. With their graceful, streamlined hulls and finely pointed bows, these craft are able to cut through the water at speed.

Special terms

As well as the parts named on page 16, the sails themselves have specific names, and there are other terms relating to sailing craft that it is also useful to know.

Gaff Pole attached to the mast and extending along the top of the fore and aft sails
Genoa Large jib on a racing yacht
Jib Triangular sail in front of the mast
Mainsail Largest sail
Mizzen lowest aft sail
Rigging Ropes holding mast and sails in place
Spar stout pole used for masts, yards etc.
Spinnaker Large sail at front of racing yachts
Yard pole across top of mast for hanging sail

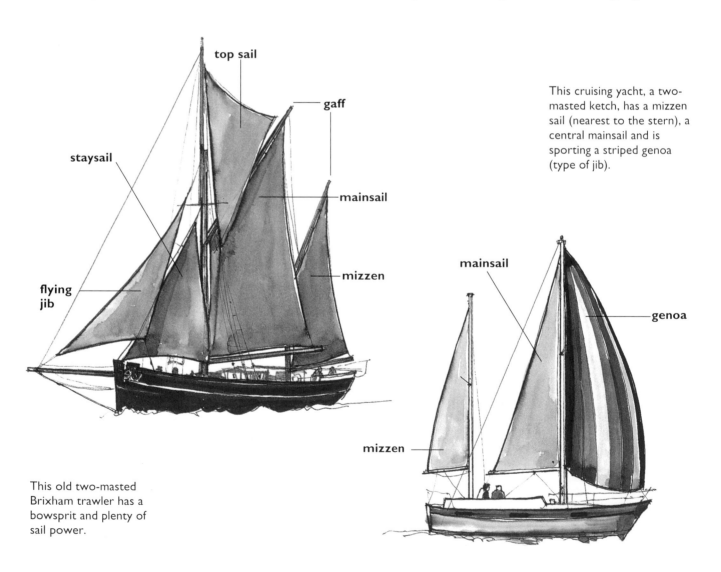

top sail

gaff

staysail

mainsail

flying jib

mizzen

This old two-masted Brixham trawler has a bowsprit and plenty of sail power.

This cruising yacht, a two-masted ketch, has a mizzen sail (nearest to the stern), a central mainsail and is sporting a striped genoa (type of jib).

mainsail

genoa

mizzen

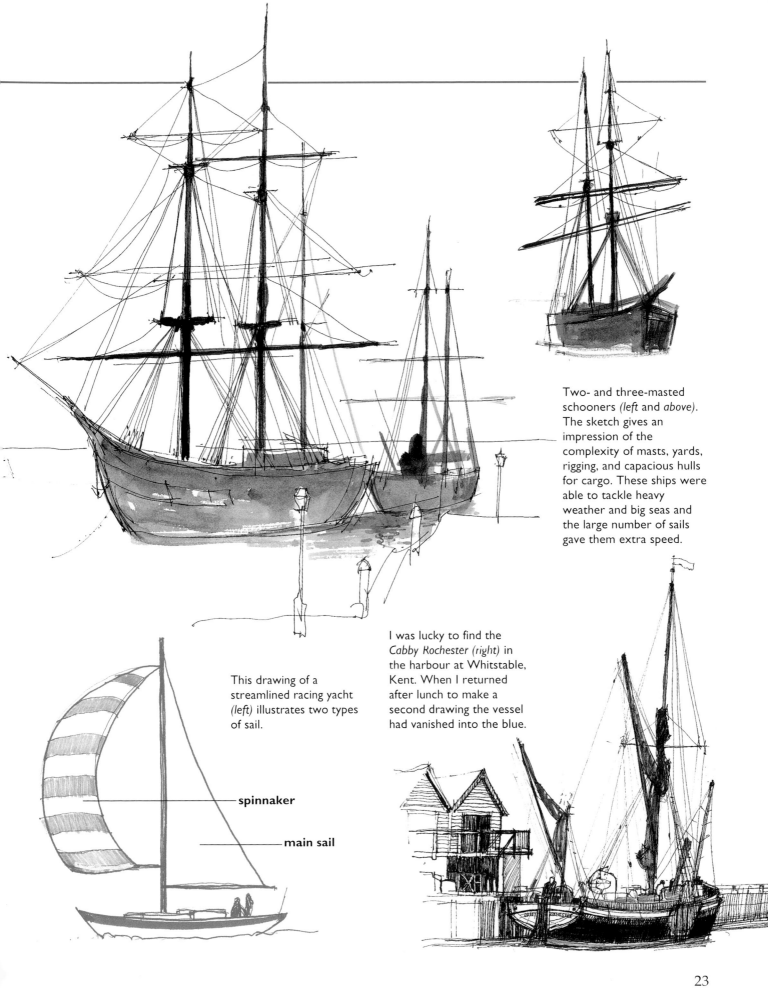

Two- and three-masted schooners (*left* and *above*). The sketch gives an impression of the complexity of masts, yards, rigging, and capacious hulls for cargo. These ships were able to tackle heavy weather and big seas and the large number of sails gave them extra speed.

This drawing of a streamlined racing yacht *(left)* illustrates two types of sail.

spinnaker

main sail

I was lucky to find the *Cabby Rochester (right)* in the harbour at Whitstable, Kent. When I returned after lunch to make a second drawing the vessel had vanished into the blue.

Boats from other countries

The boats I have chosen are from parts of the world I have visited, and have distinctive shapes which I have enjoyed drawing. The boat shown immediately below is a type of seiner, which is a traditional fishing boat in North America. The name is derived from the word *seine* which is a net with floats at the top and weights at the bottom for encircling fish. This particular type of seiner is known as a 'drum seiner' because of the drums used to winch the nets in over the stern. I made many drawings of such drum seiners at Campbell River on Vancouver Island.

The boat in the drawing at the bottom of the page is one of the famous gondolas that ply their trade along the canals of Venice. They have a unique and very graceful design which reminds me of the elegance of a swan. Gondolas are flat-bottomed, high-pointed at each end, and are worked by one oar at the stern.

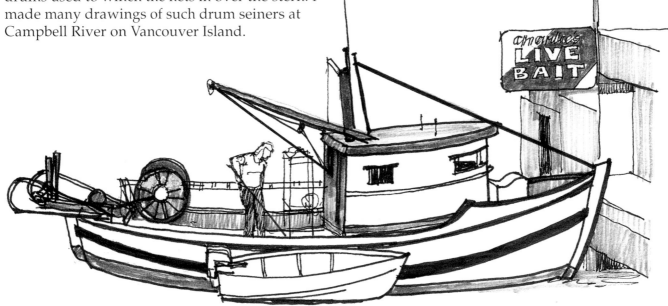

A Canadian seiner with a dinghy alongside *(above)*.

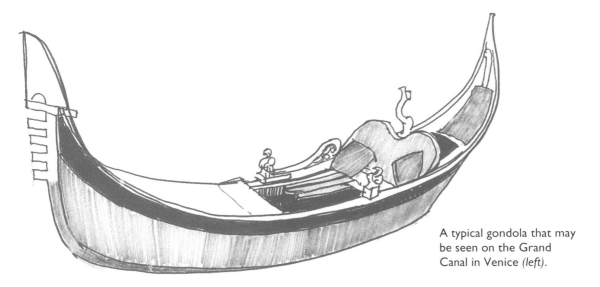

A typical gondola that may be seen on the Grand Canal in Venice *(left)*.

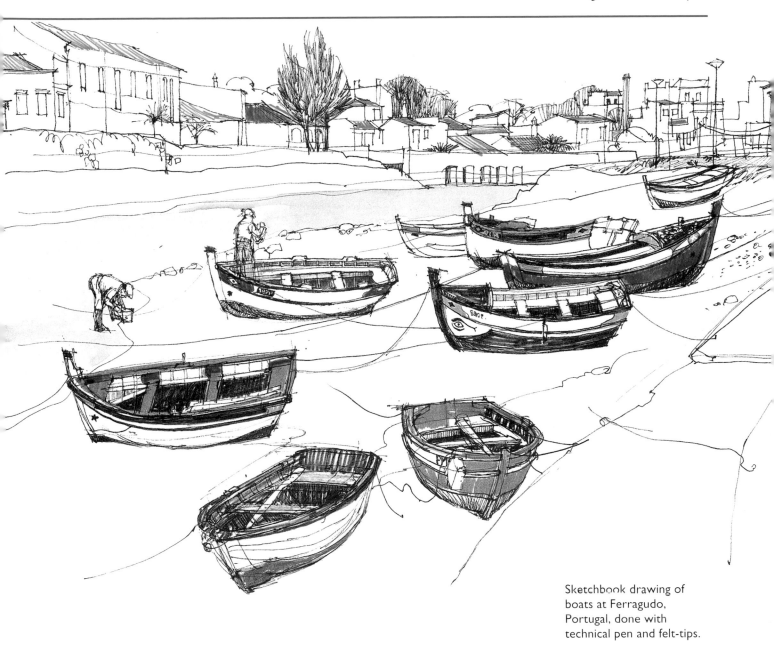

Sketchbook drawing of boats at Ferragudo, Portugal, done with technical pen and felt-tips.

Colour and pattern

The Mediterranean is home to the some of the most colourful and visually exciting boat designs. Boats may be painted with red, green, yellow and black; others with blue, red, yellow and white with a black keel, or turquoise with touches of red, yellow and blue. Stars, diamonds, eyes, fishes and circle designs often proliferate and make highly decorative subject matter – all of which is a feast for the artist's eye.

Beached in the inlet at Ferragudo in the Algarve, the boats shown above are typically Portuguese in both shape and decoration. They have unusually high, pointed prows and are brightly painted with individual symbols on their hulls. On the day I visited Ferragudo, I did not have enough variety of coloured felt-tips with me to record all the different shades I could see, so I added a few colour notes on the drawing for later reference.

Perspective

Many people feel apprehension as soon as the word perspective is mentioned, but it need not be too difficult. Perspective is the art of creating an illusion of depth and distance on a flat surface, and of making an object look solid. Objects can be made to appear three-dimensional with the use of converging lines to a horizon, getting gradually closer and smaller as they recede into the distance finally ending up as a dot on the horizon known as the vanishing point.

The horizon is the same as your eye level. If you sit down your eye level will come down with you to a low level; when you stand up your eye level (horizon) moves up with you.

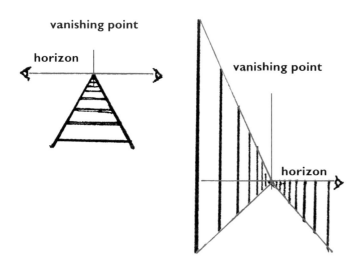

In the first diagram *(far left)* the lines which are parallel on the ground are apparently converging to a point on the distant horizon. Imagine this as a railway track: note how the spaces between the sleepers are becoming smaller as they recede, making it appear as if the sleepers are getting closer.

In the second diagram *(left)* the top of the poles are above your eye level, so the outline slopes down to the horizon. Conversely, the base of the poles are below your eye level so the outline slopes up to the horizon. The railings to the right of the track are are head-height, so the tops remain on a level with the horizon, whereas the line marking the base of the railings slopes upwards.

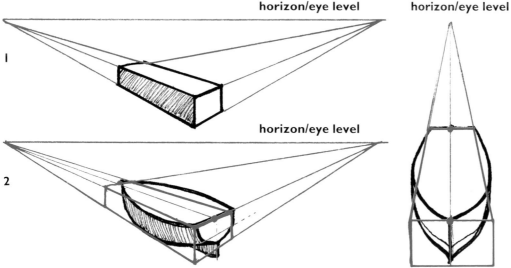

Here *(left)* we are looking down and straight at the 'brick' shape so that there is only one vanishing point. Curves are superimposed on the brick to create a boat shape.

1 A brick-shaped object below eye level, with two vanishing points, provides the basis for a perspective drawing of a boat.

2 Adding a few curved lines to the brick quickly converts it into a boat shape. Observe how the two dots (centre of stern and bow) are also on a line which converges on the vanishing point.

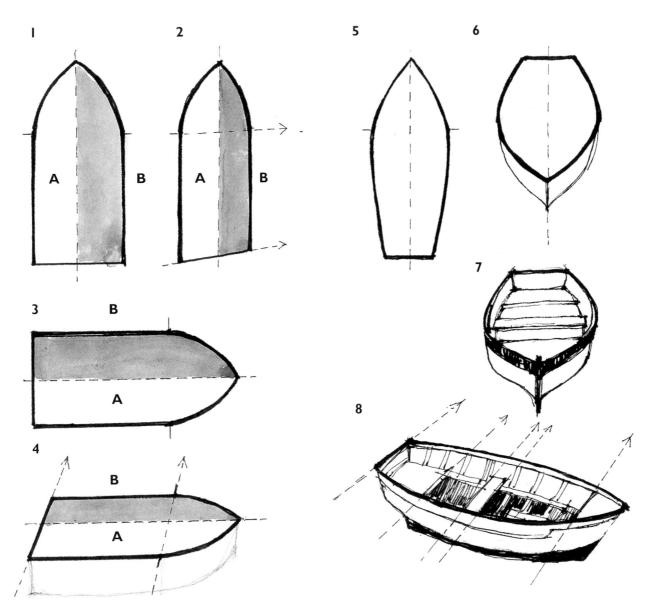

1 & 2 The basic boat shape is like an arched doorway. When the arch is viewed from different angles, perspective plays a part. In the second diagram, the arch is viewed from the side. The half of the arch nearest to me is A. B is further away and therefore slightly narrower.

3 & 4 Turn the arch on its side and you could be looking down into a boat. Tilt it and add a base and it resembles a very simple boat shape. As before, perspective plays a part, making B, the far half, appear narrower than A.

5, 6 & 7 The basic arched shape has been tapered to a smaller base to give a more refined boat shape. The refined arch shape is then turned upside-down, foreshortened and a hull added. In the final stage, the 'arch' shape is foreshortened even further. When details are added the adjusted arch shape becomes a convincing boat.

8 The perspective is obvious in this drawing, with lines in parallel appearing to converge towards the distant horizon.

The importance of eye level

How much of the inside of a boat you can see depends on where you are in relation to it. Being aware of your eye level helps you to place the horizon line, whether you have a crow's-nest view looking down at the boat, a water's edge view roughly parallel to the subject, or something in-between.

Neil Meacher's drawing of a harbour, opposite, is based on information in a sketchbook, then a design process begins to shape the drawing. It is interesting that a work such as this, so full of shape and pattern, has incorporated perspective as part of the design. The treatment of the subject is very decorative, yet all the elements are keenly observed. This is drawn from almost a crow's-nest viewpoint, with the eye level as high as the roof of the tallest building.

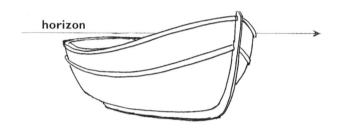

In this drawing *(left)*, the viewer is sitting on the beach and the top edge of the boat is almost on eye level. The stern drops lower than the bow, allowing a little of the interior to be seen.

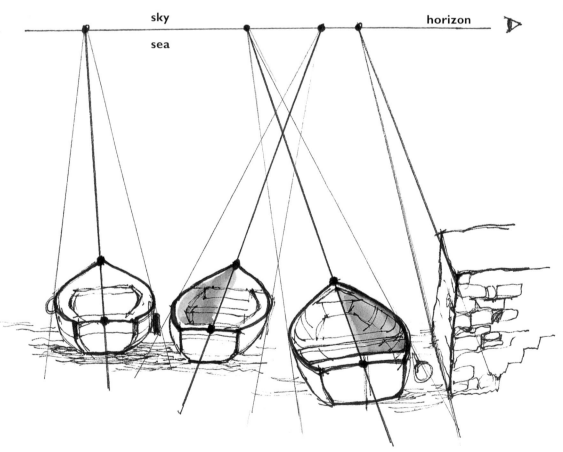

The viewer is high up above this little harbour *(left)*, looking down on the sea and into the boats, and the horizon is therefore also high. Each boat is pointed in a different direction so each has its own vanishing point on the horizon. The centre line on the two boats to the right shows that the half further from the viewer (the darker half) is smaller. The boat on the left is seen almost end-on, so the halves appear to be more equal.

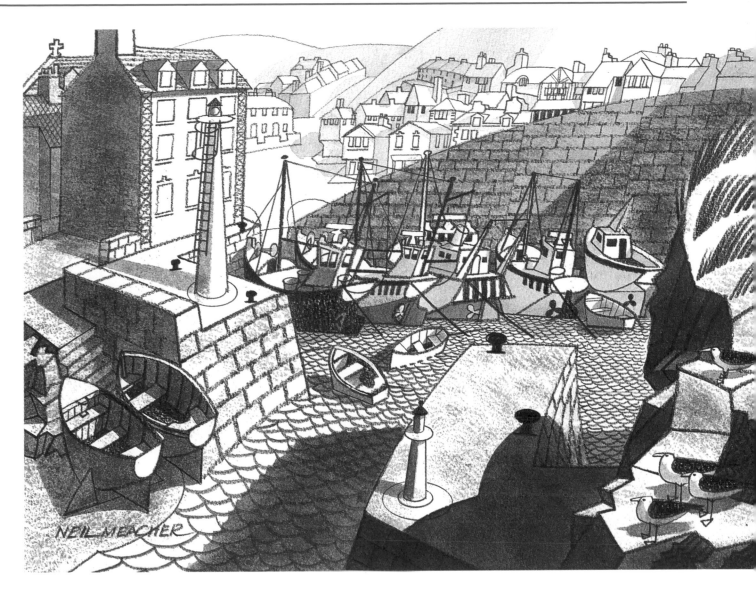

This figure *(right)* analyses
the visual perspective
within the drawing above.
The dotted lines converge
upwards and show how the
vanishing points of most
elements in the drawing
lead up to a high eye level.

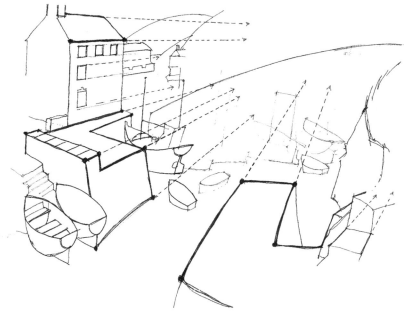

Proportion

Now that you have learned about the principles of perspective, it is time to look at how these affect proportion. Proportion refers to the correct relationship between one object and another – the distances, angles, comparative sizes and dimensions. These drawings of some small boats at Oare Creek in Kent illustrate how perspective and proportion interrelate. Looking down on the boats from my precarious perch on a gangway, I could see most of the interior of each one.

I My first drawing *(below)* shows the perspective lines that underpin the shape and proportions of the boat. I started by sketching the bare hull, comparing length to width, lightly drawing a centre line between the bow and centre of the stern section, and faintly indicating the line of the keel. I observed whether the central seat coincided with the beam of the boat, and then I estimated the positions of other seats.

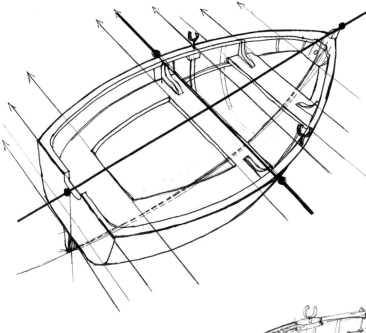

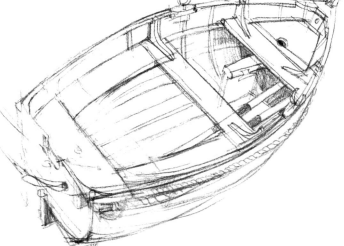

> ## Artist's Tip
>
> Hold your sketchbook vertically in front of you and at arm's length. The edges can be used to check up on horizontals and verticals.

2 Having established the basic shape and proportions, I was able to work in the details *(below)*. Note how the rowlocks are situated on line opposite each other. This may not seem important, but it is a perspective detail that helps to make a drawing convincing.

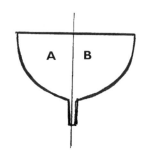

I A direct view of a transom (stern section) of a boat. Each half is equal.

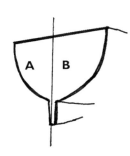

2 The transom viewed from the side. The halves are no longer equal: the nearest half B is larger than A.

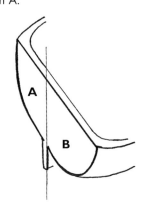

3 The final diagram of the transom shows how this principle applies to the drawing of the boat on the left.

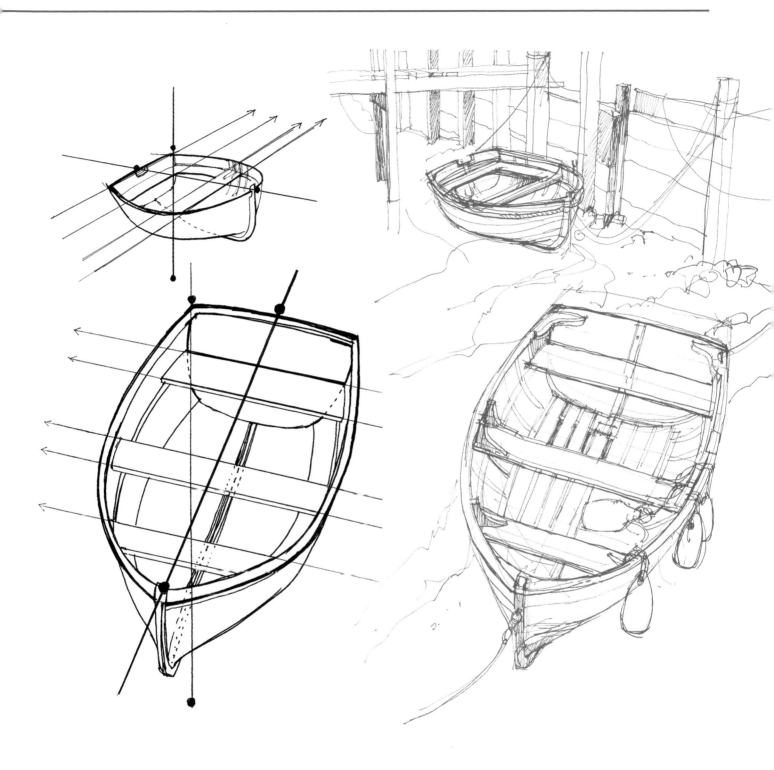

1 The nearer boat is seen almost straight on, so any convergence of the parallel lines is hardly noticeable and there is very little difference between the widths of the two halves of the boat. The rear boat is viewed from a much lower eye level, making the nearer half much wider than the far half.

2 As the drawing developed, I kept checking it using verticals and horizontals. For example, looking at the rear boat, taking a vertical from the far corner of the stern cuts the nearer gunwale almost in half, whereas in the boat in front the far corner is not far from being in line with the bow.

Comparing proportions

The drawings on these two pages are of a fishing boat I found in a small harbour at Burnmouth on the east coast of Scotland. Although the first view is simple, seen from the side with no perspective involved, comparisons still need to be made of proportions.

As you develop your drawing, keep using different points as markers to check relative heights and widths. For example, is the roof of the cabin higher the prow? How does the height of the rudder compare with other parts of the boat? Making such judgments will become easier as your experience grows.

1 I began by sketching the overall shape of the hull, noting the difference between the height of the bow and the stern. I then placed the cabin judging whether it was centrally located or nearer to the bow or stern. As a further check, I compared the position of the cabin with the centre line of the hull. I also compared the height of the mast to the cabin and to the length of the hull.

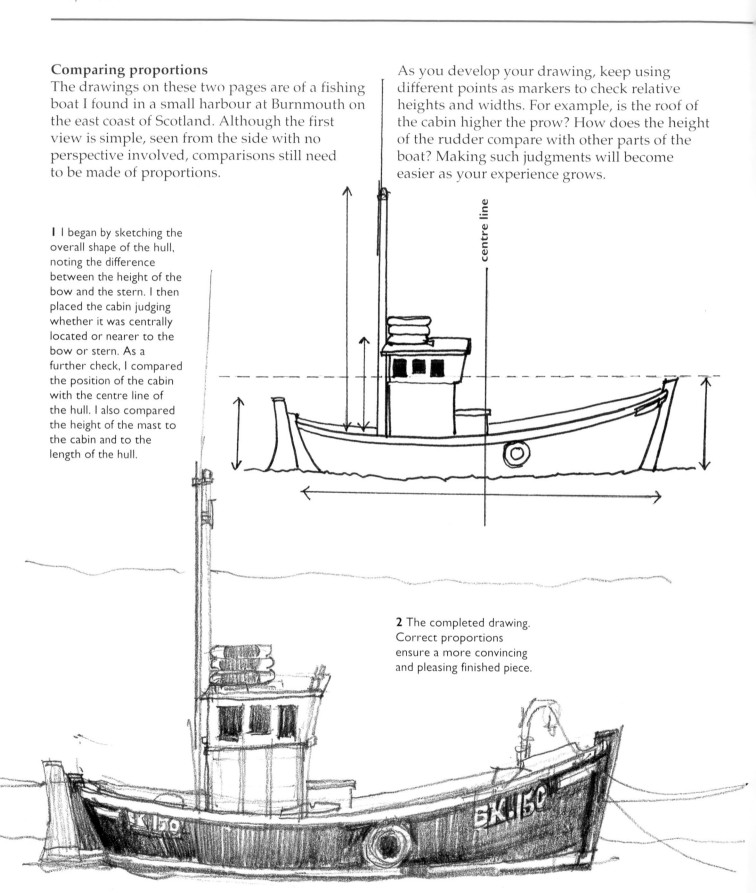

centre line

2 The completed drawing. Correct proportions ensure a more convincing and pleasing finished piece.

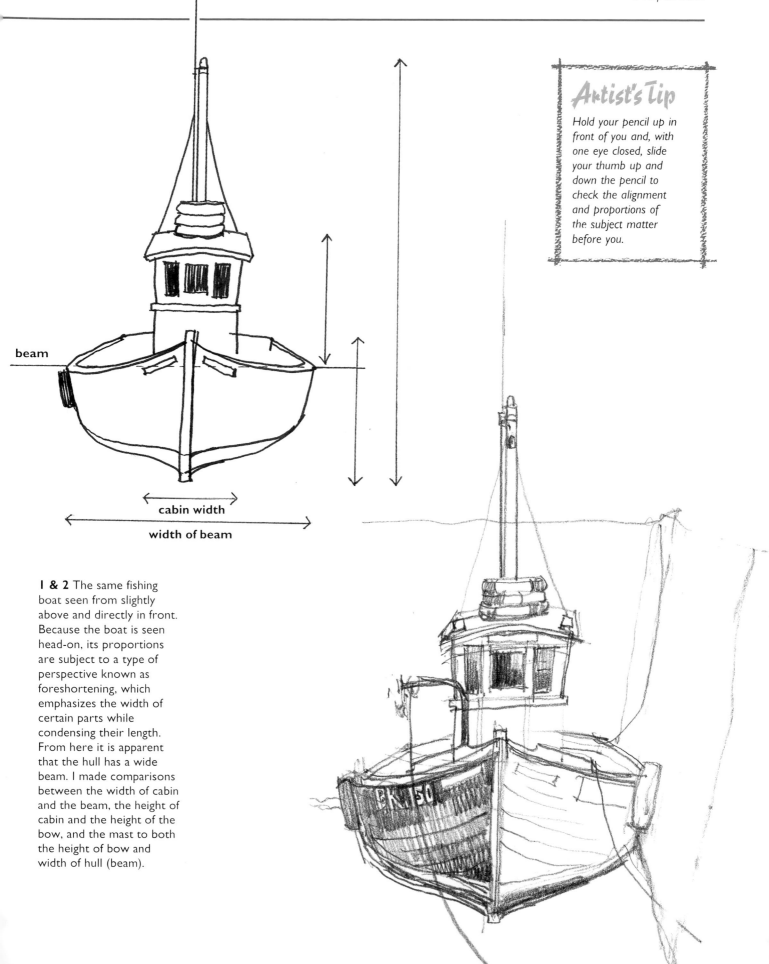

beam

cabin width

width of beam

1 & 2 The same fishing boat seen from slightly above and directly in front. Because the boat is seen head-on, its proportions are subject to a type of perspective known as foreshortening, which emphasizes the width of certain parts while condensing their length. From here it is apparent that the hull has a wide beam. I made comparisons between the width of cabin and the beam, the height of cabin and the height of the bow, and the mast to both the height of bow and width of hull (beam).

Training your eye

It sounds laborious, but after a while you will find that constant checking as you draw, and making comparisons which link each part of the subject, becomes an automatic habit.

Here again is the fishing boat in Burnmouth harbour, this time viewed from different angles which involve some perspective. The principles of perspective have already been discussed, but it is possible, with very careful observation and the use of horizontal and vertical guides, to pinpoint different parts of the boat and produce an accurate drawing without having any knowledge of the theory of perspective.

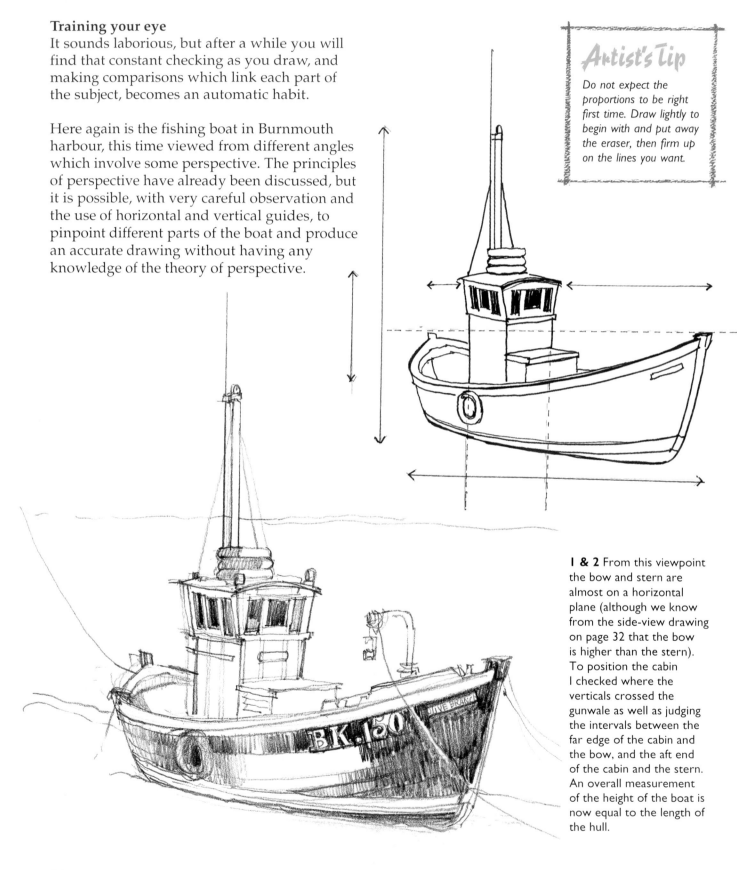

Artist's Tip

Do not expect the proportions to be right first time. Draw lightly to begin with and put away the eraser, then firm up on the lines you want.

1 & 2 From this viewpoint the bow and stern are almost on a horizontal plane (although we know from the side-view drawing on page 32 that the bow is higher than the stern). To position the cabin I checked where the verticals crossed the gunwale as well as judging the intervals between the far edge of the cabin and the bow, and the aft end of the cabin and the stern. An overall measurement of the height of the boat is now equal to the length of the hull.

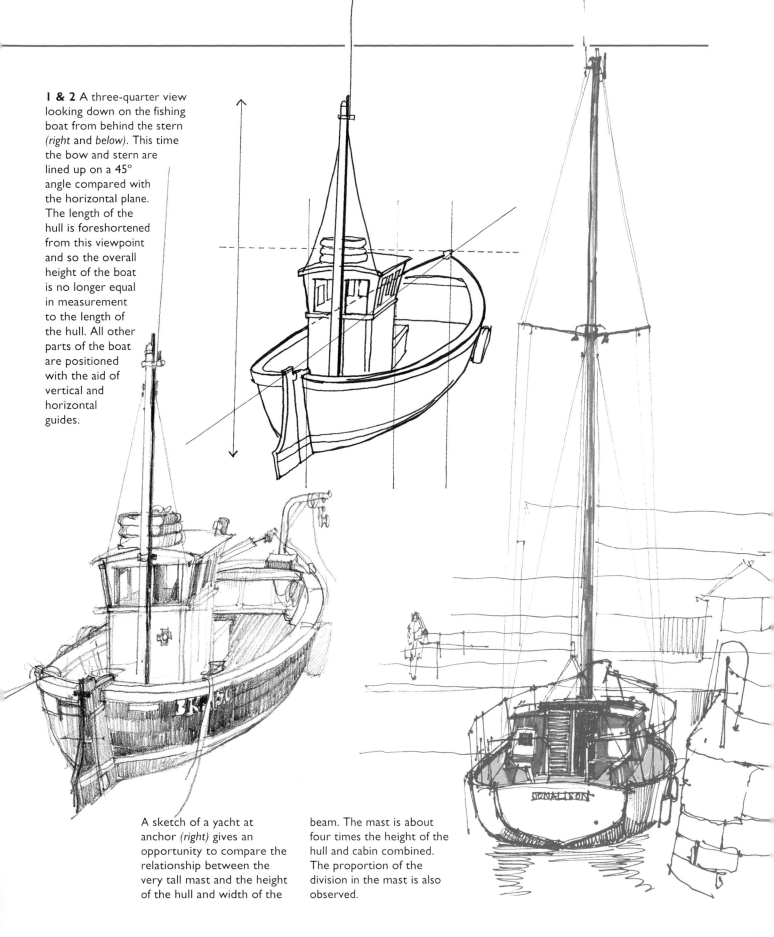

1 & 2 A three-quarter view looking down on the fishing boat from behind the stern *(right* and *below)*. This time the bow and stern are lined up on a 45° angle compared with the horizontal plane. The length of the hull is foreshortened from this viewpoint and so the overall height of the boat is no longer equal in measurement to the length of the hull. All other parts of the boat are positioned with the aid of vertical and horizontal guides.

A sketch of a yacht at anchor *(right)* gives an opportunity to compare the relationship between the very tall mast and the height of the hull and width of the beam. The mast is about four times the height of the hull and cabin combined. The proportion of the division in the mast is also observed.

Light and Shade

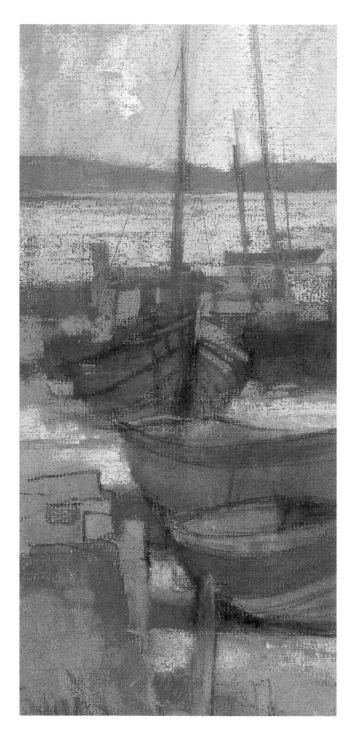

The representation of light and shadow in a picture is known as tone. Light falling on an object will define its surface and model the form. The resulting gradation of tone from light to dark helps to create an illusion of space and three dimensions. An extreme tonal range progresses on a scale from black to white, whereas a 'high key' moderate range of tone may extend from, for example, mid-grey to very pale grey without any strong contrasts. Hence different atmospheres can be created from dramatic light and shade to soft muted light with subtle shadows.

Artist's Tip

Drawing on toned paper and adding highlights enables you to achieve an instant tonal effect.

I used thin and thick felt-tips to add tone to this pen drawing of Staithes harbour in Yorkshire *(right)*. The tonal range goes from the black of the ink to the white of the cartridge paper. Broad felt-tip pens are very useful for adding quick tonal effects to a drawing, but remember that they are not always permanent. They are, however, good for a working sketch.

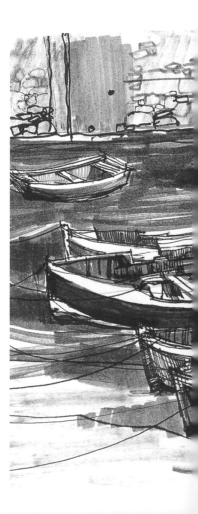

I drew these boats at Abereiddy in Wales *(above)* with pastel pencil on mid-toned, grey pastel paper. Light and shade were added with soft pastel. The tonal range is gentle, with no extremes – the darkest tones are not black and the lightest are not pure white.

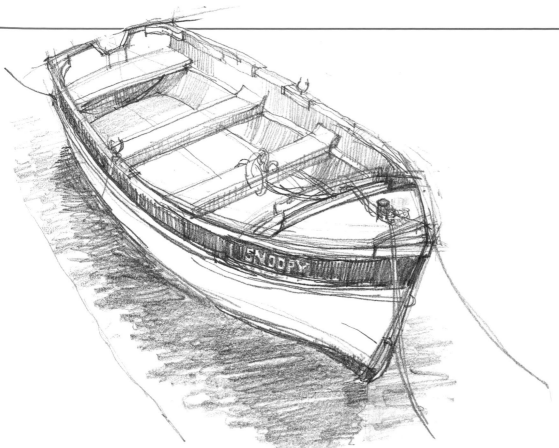

This drawing of a boat in the harbour at Seaton Sluice, Northumberland, was done with a 4B graphite pencil *(left)*. The tonal gradations were made by varying the pressure on the pencil to make lighter or darker lines, and by close spacing of lines in the darker areas and open spacing in the lighter areas. Note that some of the initial exploratory lines have not been erased. Leaving such lines involves the viewer in the development of the drawing.

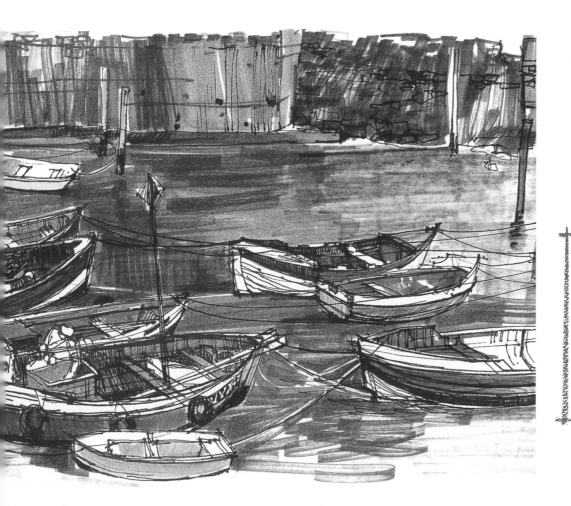

Artist's Tip

Remember to leave areas of light and shade in your detailed drawing. A soft putty rubber will gently erase graphite pencil. In pen and ink wash, white paper will provide the lightest tone.

Aerial Perspective

Aerial perspective is a rather misleading term for it has little to do with the type of perspective described on pages 26–29. It is, in fact, the name given to changes in tone and colour values as objects recede into the distance. If corresponding variations are made on a flat piece of paper, an illusion of depth and distance can be created.

Fading into the distance

Because of our atmosphere, colours become more muted and tend towards blue in the distance. Darks are darker in the foreground, becoming gradually lighter in the distance, and the amount of detail fades to insignificance the further away an object is. This 'tonal recession' depends on the clarity of light, so it can vary in different parts of the world.

Creating tonal variations

Even if you only have one pencil you can still produce tonal differences by varying the pressure you apply. With both pencil and charcoal, smudging with a finger or rag will give a softness to distant tones. You can also partially lift off areas with an eraser. With watercolour, start in the distance with very dilute washes and gradually add more colour to strengthen the wash until foreground objects are darker.

Charcoal and white conté on mid-grey Ingres paper has been used for this harbour scene. The strongest contrasts are in the foreground where black and touches of white have been applied. In the background, blending charcoal with a finger has achieved softer tones, while lifting off charcoal with a putty eraser gives hints of distant houses.

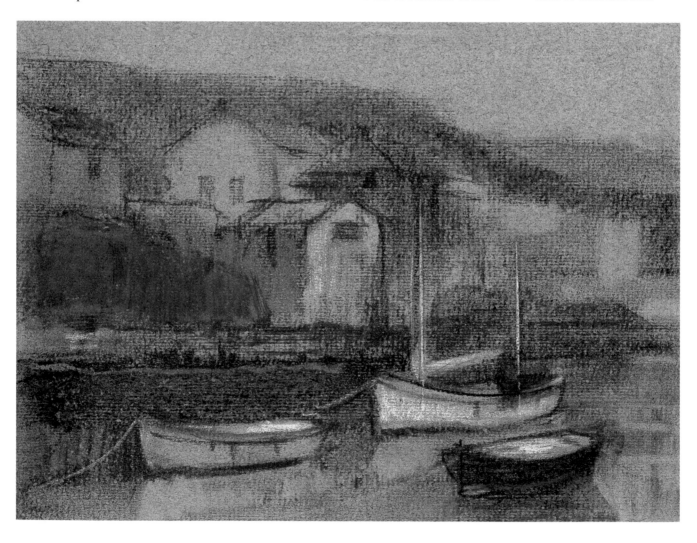

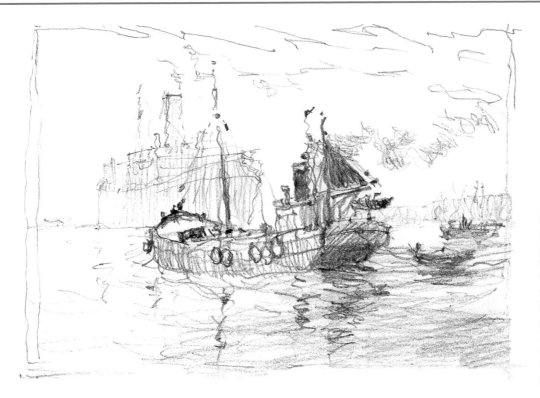

Gordon Hales' lively pencil sketch on a piece of scrap paper *(left)* clearly shows tonal differences between the fishing trawler in the foreground and the soft light grey tones of the large steamship further away. Details are only hinted at on the steamship whereas details on the fishing trawler are easily seen.

This watercolour 'doodle' *(right)* illustrates simple areas of tone becoming progressively lighter in the distance. The darkest darks are the silhouetted shapes of sailing dinghies in the foreground.

Reflections

Reflections throw back the image of a subject on the smooth surface of water, which can act like a mirror until a wind or the fluid motion of waves disturbs that surface and breaks into the reflection. If the movement in the water becomes stronger, the reflection will gradually disappear.

Surface distortion

Still water is more likely to be found in a harbour where the surface can be smooth enough to give very clear reflections. In the wash drawing of the two boats below, the weather seems fairly calm – just a hint of ripple in the water. A few horizontal brushstrokes have been used to denote the water's flat surface. This drawing is highly atmospheric, the last of the evening light silhouetting the simple shapes of the boats. In the subtle light approaching dusk, very few details can be seen on the boats and this also applies to the reflections which are soft-edged.

The reflection of the boat anchored in the bay at the bottom of the opposite page shows considerable distortion because the movement

in the sea has broken up the image – you can almost hear the lapping of waves against the hull. The wonderful effect of sparkling light created in this watercolour sketch by Gordon Hales is almost dazzling.

Tone in reflections

Reflections always have less intensity of both colour and tone than the objects they mirror, so a reflection of a dark hull will be a little lighter in tone, whereas the reflection of a white hull will be slightly darker in tone. This effect is seen in the gouache drawing opposite, with the white-sided rowing boat in the harbour and the dark vertical posts supporting the quay. Their reflected image is not as dark as the posts themselves, whereas the reflections of the white boat is not as light in tone.

The effect of perspective

Perspective also plays a part in reflections. In the case of the white boat opposite, we can see inside, but the view from the reflection in the water will be below the boat, therefore the interior will not be seen in the reflection.

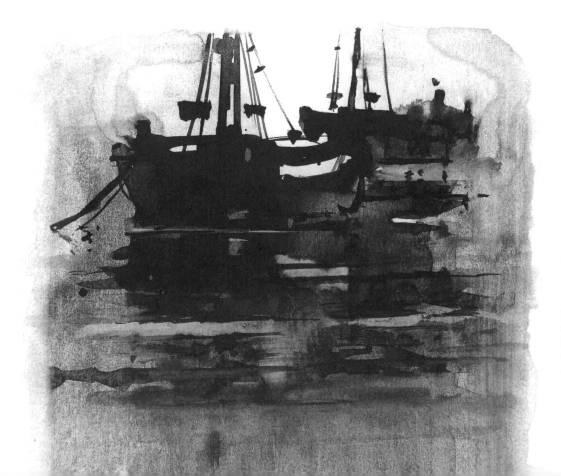

Ripples appear to be closer together in the distance and so there are wider gaps between ripples and a wider reflection as it comes towards you.

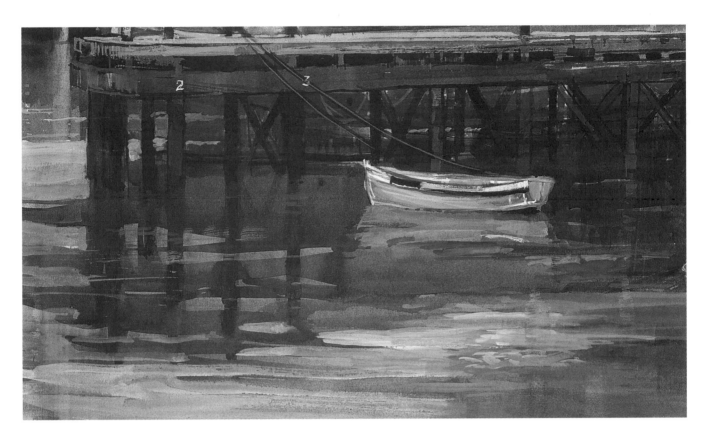

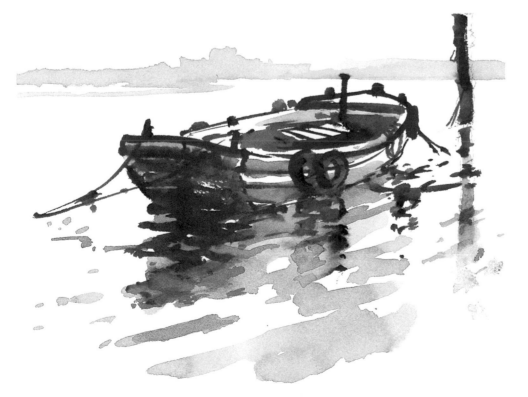

Vertical poles have vertical reflections *(above)*. If the water surface is very disturbed, these will of course be broken up.

A pole or mast that leans will have a reflection that leans to the same side *(left)*. Note the aerial perspective, which Gordon Hales has produced by brushing in the distance as a simple, pale silhouette with no detail, whereas the boat is sharply defined with contrasts of light and dark and visible details.

Looking at Details

Marine paraphernalia and motifs can be very decorative as well as being functional. There are often abstract elements, interesting shapes, design and pattern that can inspire imaginative painting as well as being rewarding to draw.

Convincing the viewer

When a subject is distant and details are vague, it helps to have acquired some knowledge of the structure of boats and their parts, so that a mere suggestion of a detail will be convincing to the viewer. Although much can be omitted when drawing distant craft, the suggestion of details in a general view should look right. For instance, a dot on the rigging of a sailing ship should give the impression of a shackle and add authenticity to a sketch. Ideally it is good if our marine subjects can satisfy the eye of the seaman with enough accuracy, but at the same time have painterly qualities.

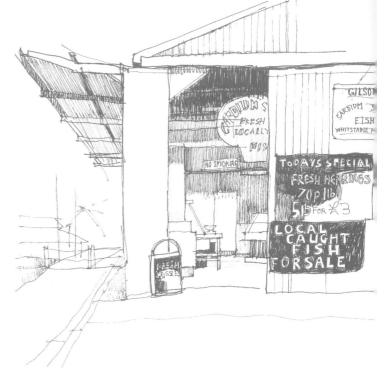

Quaysides provide many interesting details such as bollards, coils of rope, handrails, floats, lobster pots and, of course, seagulls. The plethora of signs at the fish market on the quayside at Whitstable, Kent, caught my eye *(top right)*. I hurried to record the shape and pattern of the lettering which was more important to me than the actual words. The lettering may not have been perfect, but the graphic quality, spontaneity and variation gave it a vitality that more carefully executed lettering would not have had.

Fishing boats at Eyemouth in East Berwickshire *(right)* provided plenty of interest on deck, and I was soon engrossed with the picture-making possibilities of machinery and the pattern of masts.

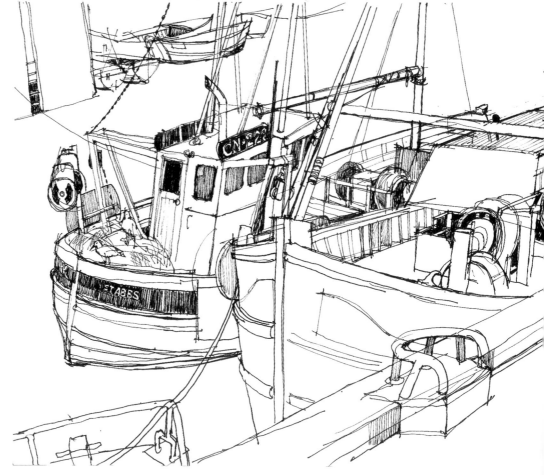

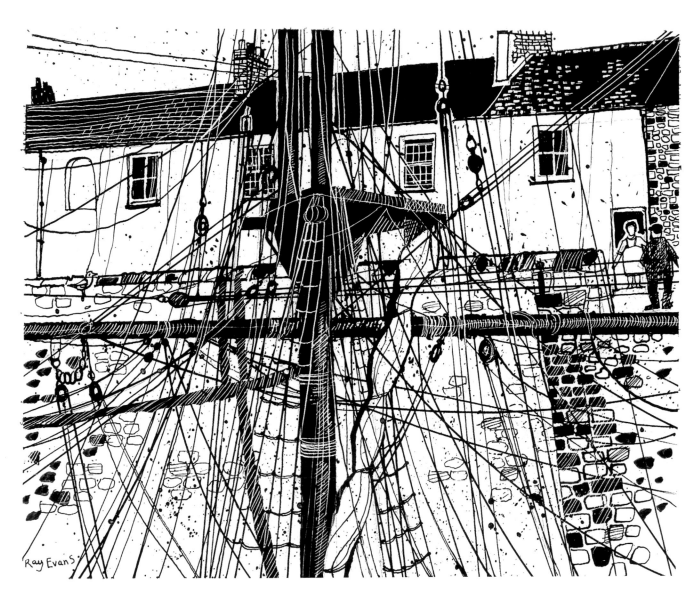

Ray Evans

There is not a ship in sight in Ray Evans' scraperboard drawing *(above)*, but the subject could not be more nautical with its linear pattern of masts and rigging, blocks and tackle, pulleys and furled sail. The main composition is simple, based on a cross formed by the main mast and yardarms. Scraperboard is ideal for very fine lines of rigging. Note the counter-change from black to white to black again, as rigging lines cross in front of the roofs of the houses.

In any boatyard or on any quayside, there is plenty of nautical paraphernalia – capstans such as this one *(right)*, lobster pots, oars, buoys, etc – for the artist to sketch.

Texture

Texture produces an interesting surface, giving a tactile and sometimes three-dimensional effect within a drawing.

You can create texture in many ways: for instance, you can 'draw' the texture of an object by making appropriate marks, or you can exploit combinations of media and surface – soft pencil, pastel and charcoal will show the graininess of paper, for example; or you can make use of the interaction of different media, setting textured marks against smooth. Textures should relate to the character of the object, so choose your technique accordingly.

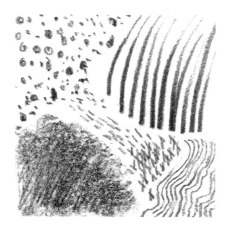

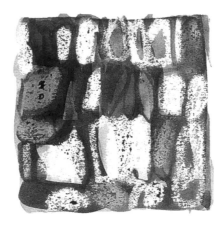

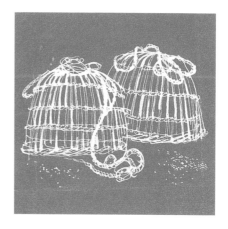

Many textural marks can be made with pencil *(above)* – dots of different sizes, rhythmic lines, hatching (criss-crossing lines), lines of varied thickness and density, and pencil scumbled (rubbed) over the surface.

Watercolour and candlewax is an ideal combination of media for the texture of crumbling paintwork, rocks or harbour walls shown here *(above)*. First, wax is applied to the paper followed by washes of watercolour. Most of the watercolour is repelled by the wax but a few globules of paint will adhere to give an interesting texture.

These lobster pots *(above)* were drawn with a dip pen and white ink on a dark paper, which seemed appropriate for the fine details of basketwork.

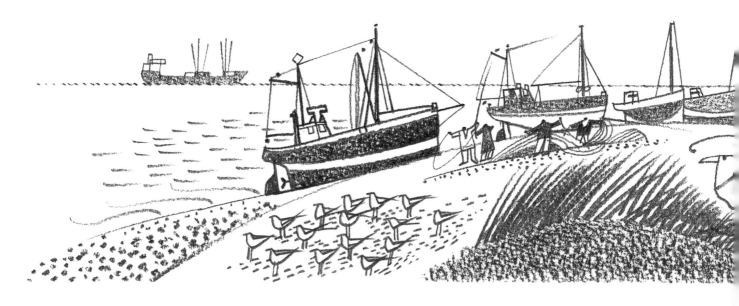

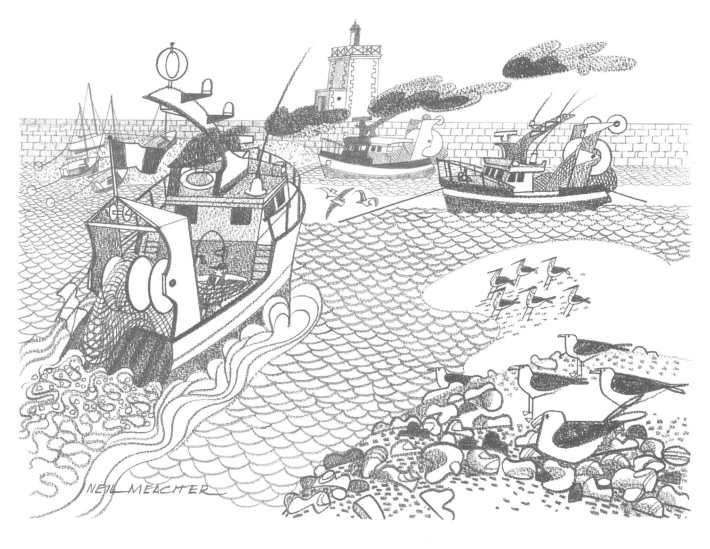

The combination of media and marks in these two drawings by Neil Meacher (*above* and *left*) creates a strongly textured interpretation of the subject matter. The drawings were made on heavily grained watercolour paper, and many of the same pencil marks demonstrated on the far left of page 44 were used in both of these drawings.

Composition

The aim of composition is to achieve an interesting picture that appears balanced to the eye of the onlooker, resulting in a satisfying piece in which nothing seems out of place.

The basics of composition
After selecting a subject, keep in mind what it was that attracted you to it in the first place and

A boat placed centrally and the horizon across the

concentrate on that. Do not make your drawings too small, and avoid drawing a row of boats along the bottom of the paper – remember that the whole area of the paper is part of the composition. In the end, though, there are no real rules about picture-making; it is all a question of whether the spatial relationships look 'right' on the paper.

The Golden Mean
The placing of the horizon and the position of the boat can be an important factor in a composition. The first diagram on the left shows an uninteresting composition; a better placing is shown in the two diagrams below, where the horizon is either above or below centre and the boats are placed away from the centre.

The mathematical formula known as the Golden Mean can help to achieve a perfectly balanced composition, and it has been used in many works of art. For the mathematically inclined, this formula states that a line should be divided so that the small part is to the larger, what the larger part is to the whole. For example, the ratio of 5 to 8 is the same as the ratio of 8 to 13, as shown in the two diagrams below.

middle make for a rather static composition *(above)*.

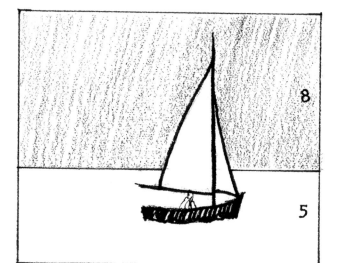

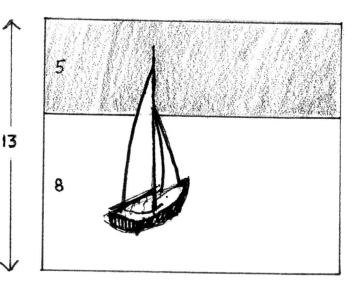

Two compositions based on the Golden Mean *(above* and *above right)* make for more pleasing pictures.

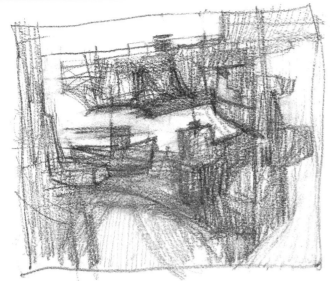

Whether you are doing a drawing that will exist in its own right, or using it as a basis for a painting, it can be useful to work out ideas beforehand with a series of small 'roughs' which try to balance shape and tone, and find a satisfactory arrangement. I used charcoal on a scrap of watercolour paper *(left)* to work out the composition for my painting 'Harbour Boats' *(below)*. Here, the horizon is high to allow the shape of the harbour to dominate the composition and enclose the boats.

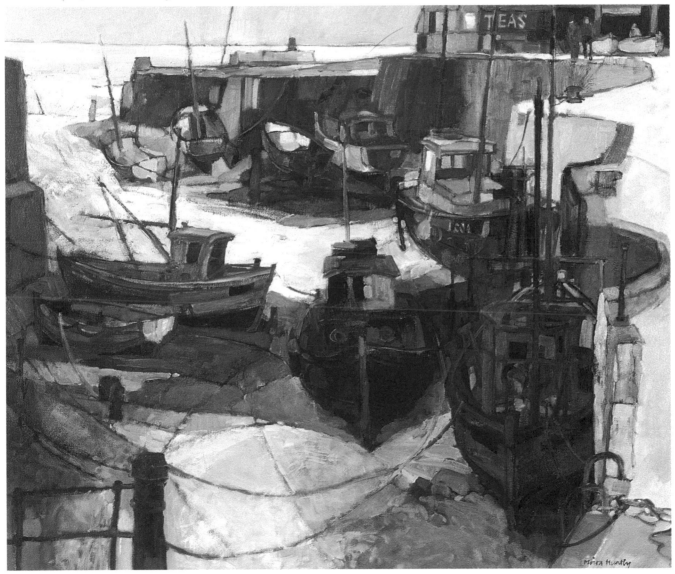

In Setting

Boats and figures

Many boats are working vessels so figures are often an integral part of the scene – but this can mean having to sketch quickly to capture the moment. Some marine tasks, such as mending nets, loading and unloading, are repetitive so a moving figure may revert to the same position several times, making it easier to complete a drawing. A favourite pastime for holidaymakers is standing on harbour walls watching the activities below, and this provides the artist with another opportunity to make studies of people and boats.

Saturday afternoon in a small fishing village in the Algarve – fishermen working on their boats and nets, some just chatting, made an ideal sketching subject *(below)*. The day was hot and the large umbrella was a practical as well as a decorative feature.

Fishermen heading for an early boat in Lyme Regis, Dorset *(right)*. There was plenty of character for Ray Evans to draw here: you can almost smell the bait.

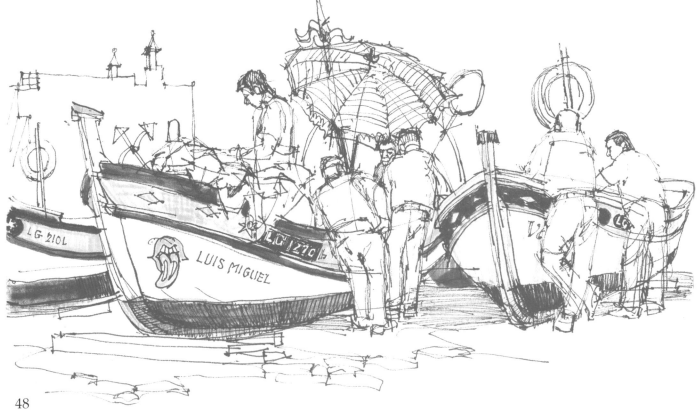

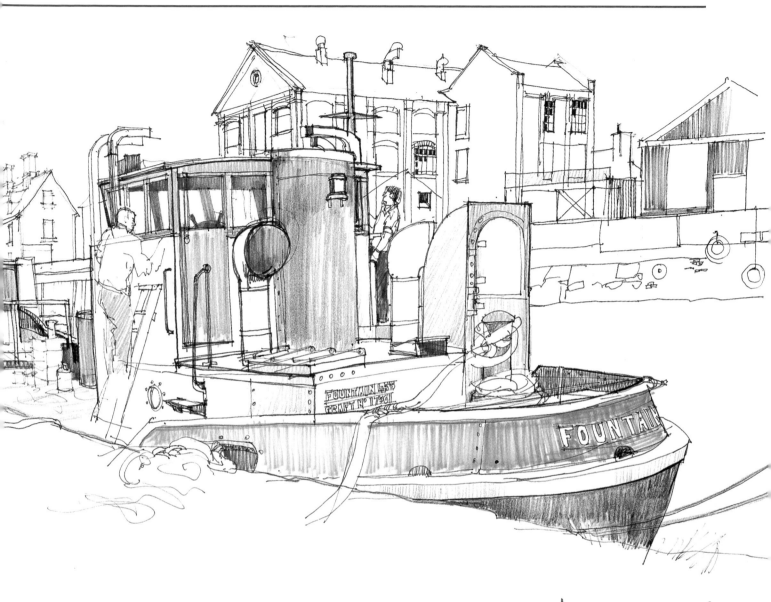

The right scale

The inclusion of figures not only gives life to a drawing, but also gives scale to a boat. Make sure, though, that both are in the right scale in relation to each other: the figure you have drawn should be neither a midget, nor a giant that is too big to go through the doorway. To get the proportions right, compare the height of the figure to the height of the boat, and relate it to a feature on the boat such as the cabin door.

A very different Saturday afternoon in Heybridge Basin in Essex provided an opportunity to sketch the men cleaning up their vessel *(above)*. I used pencil to add some tone to this pen and ink drawing, to help distinguish the marine subject from the architectural features in the background.

Artist's Tip

When drawing in the harbour, establish the general outline of the boat relative to the height of the quay before adding any details, as the outline will change with the rising and falling tide.

Boats in groups

Before starting to draw a large group of boats, decide which aspects of the group attracted you most and try to judge how much of this you can get onto your paper. Position the first boat on the paper, drawing its overall shape without details, then gradually add the surrounding boats, comparing heights and widths of each one with the first boat. Remember to take the spaces between the boats into account, too.

These boats clustered together by a quayside, beached dinghies, and boats in a harbour at low water were all sketchbook studies using a technical pen, and felt-tip pens for colour notes.

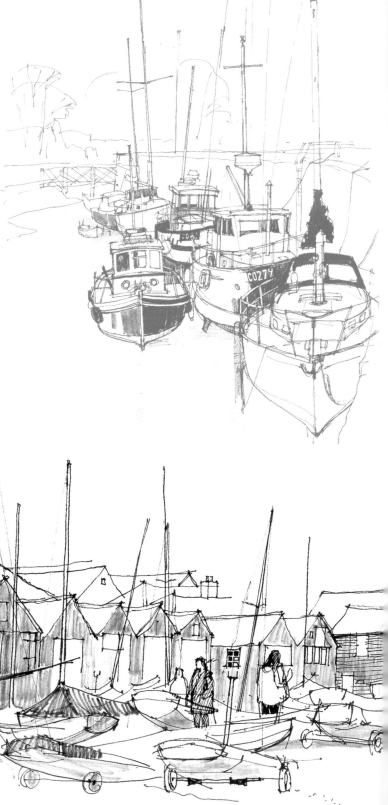

Buildings along the waterfront at Whitstable in Kent, with a forest of dinghy masts in the foreground and a few figures wandering about, made a good subject (below). Before I began, I had assessed the panorama and knew that it would run onto two pages. I started the drawing on the left-hand side and gradually extended it until it reached the sea.

This jumble of yachts and fishing boats at Caernarfon in Wales (above right) attracted me in abstract terms – their patterns and shapes, the intervals between masts, and the graphic details such as lettering, floats and fenders. Every cabin is different and the masts are at slightly varying angles.

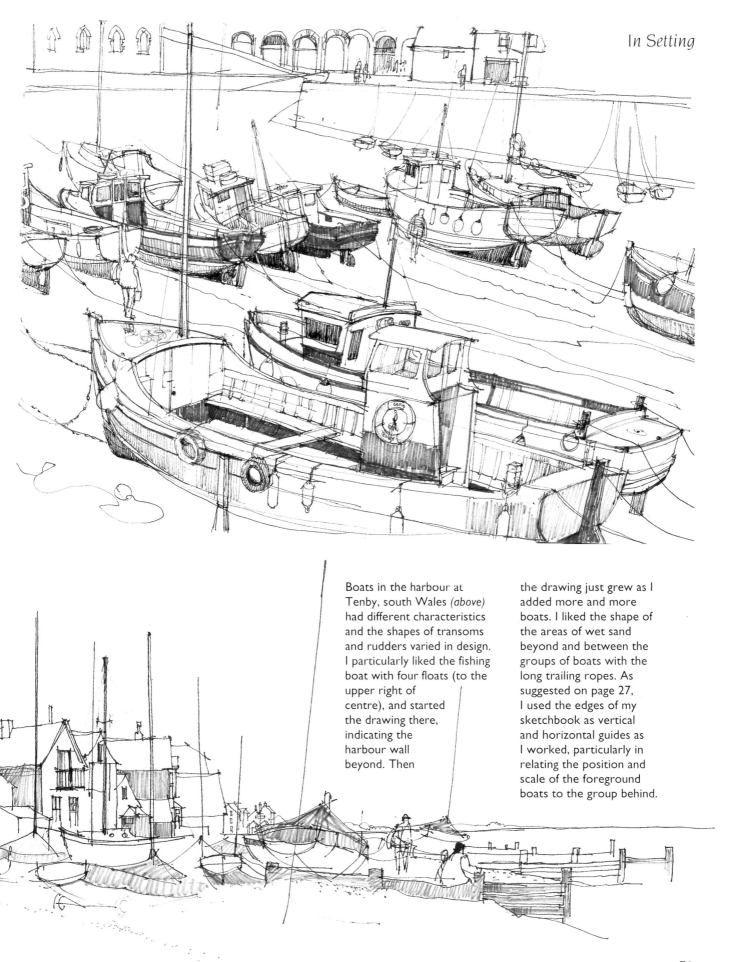

Boats in the harbour at Tenby, south Wales (above) had different characteristics and the shapes of transoms and rudders varied in design. I particularly liked the fishing boat with four floats (to the upper right of centre), and started the drawing there, indicating the harbour wall beyond. Then the drawing just grew as I added more and more boats. I liked the shape of the areas of wet sand beyond and between the groups of boats with the long trailing ropes. As suggested on page 27, I used the edges of my sketchbook as vertical and horizontal guides as I worked, particularly in relating the position and scale of the foreground boats to the group behind.

Sketching

Outdoor sketching has many hazards – onlookers, midges and other insects, boats putting to sea before you have completed your sketch and, of course, the weather – so it pays to be well prepared before you set out. When I am travelling light, my minimum equipment would be a sketchbook, waterproof pens, coloured pencils or felt-tips, a 2B pencil, a protected blade for sharpening the pencil, and a folding, lightweight stool.

I sketched this harbour scene in Gloucester, Massachusetts, using felt-tips and waterproof pens.

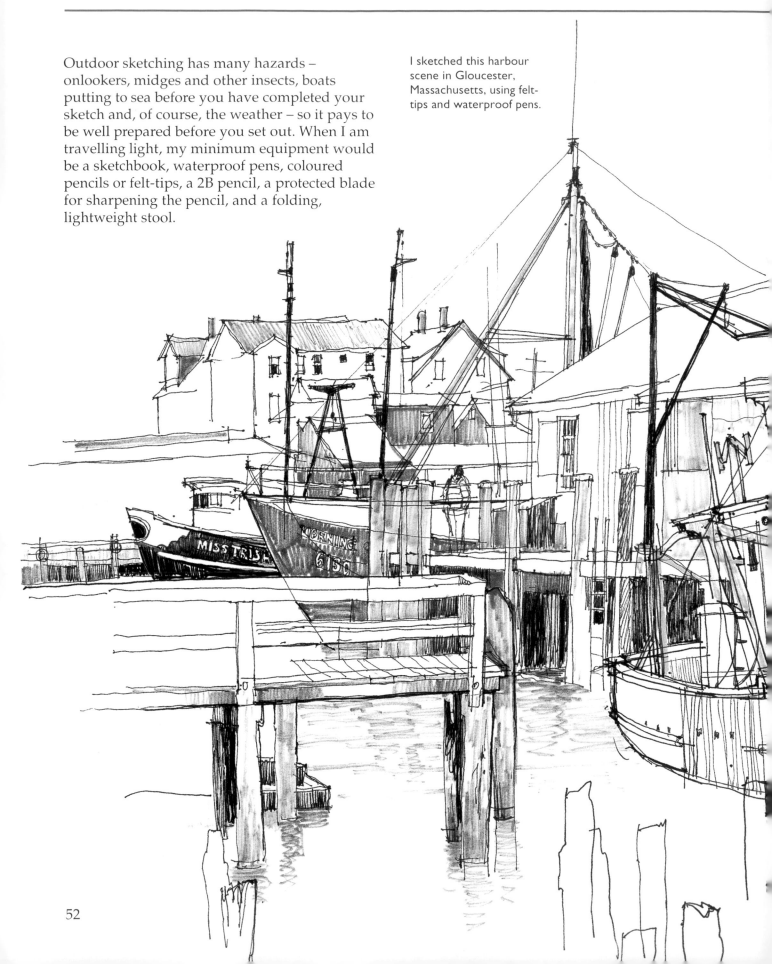

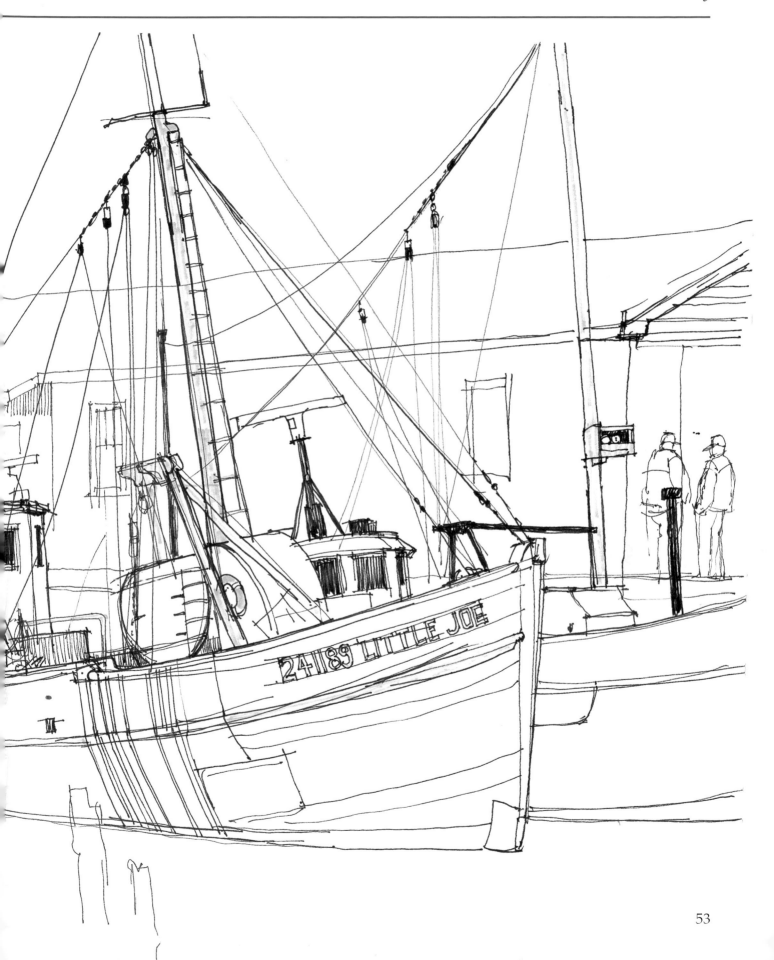

Other sketching equipment

If a location is easily accessible and you can park a car nearby, you may want to extend your range of sketching materials to include a watercolour box and brushes, a plastic jar and plastic screw-top bottle of water, a folding easel and ready-cut paper clipped to a board. With watercolour, lightweight paper will cockle and so it is better to take a heavier paper such as 300gm²/140lb NOT, or watercolour board.

Boatyards

Very often we are looking down on boats, but sketching in a boatyard gives us the opportunity to view boats from a low eye-level and look up at them. We can observe the shapes of keels, rudders and propellers at first hand and often get the chance to include figures working on the hulls to keep the boats seaworthy. A bonus is that the boats are stationary and will probably still be there next day.

Quaysides

When drawing on a quayside where there is plenty of activity, it is important to find a vantage point where you can keep out of the way, especially if loading or unloading is taking place. I usually watch for a while to see the routine and how much space is used by the men, before picking my spot.

Fishermen's Wharf in Seattle was an easy boatyard to gain access to *(below)*. I liked the tubby character of the *Betty B*. Yard workers came and went, then two of the men returned to work on the hull, so I simply superimposed them over the propeller and keel that I had already drawn.

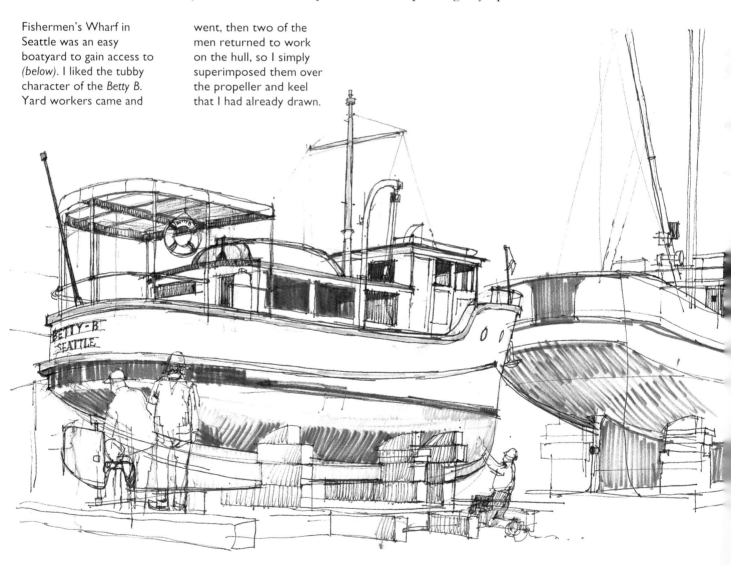

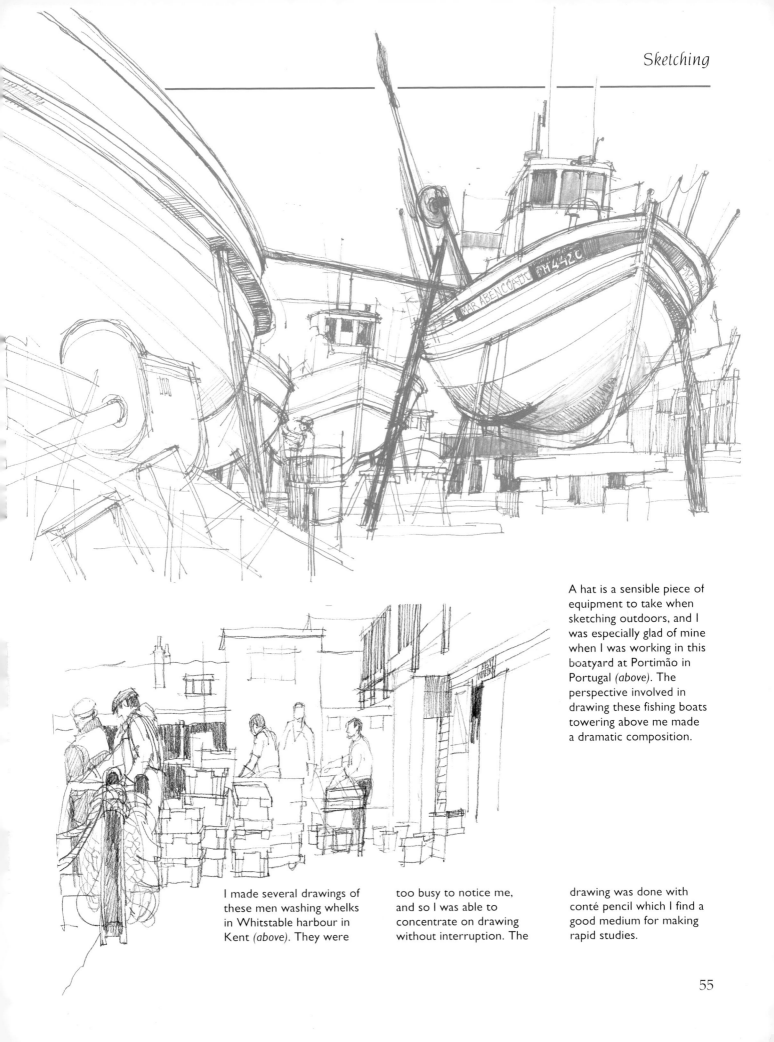

A hat is a sensible piece of equipment to take when sketching outdoors, and I was especially glad of mine when I was working in this boatyard at Portimão in Portugal *(above)*. The perspective involved in drawing these fishing boats towering above me made a dramatic composition.

I made several drawings of these men washing whelks in Whitstable harbour in Kent *(above)*. They were too busy to notice me, and so I was able to concentrate on drawing without interruption. The drawing was done with conté pencil which I find a good medium for making rapid studies.

Dockyards

Nowadays dockyards are more security-conscious. You cannot always just walk in, so it is wise to have some means of identification on you and, if necessary, telephone beforehand to ask for permission to draw.

Scale becomes a challenge when you are close to large ships. The inclusion of buildings, sheds, cranes or figures in a drawing provides a means of showing the comparative size of the ships.

Coasters and cargo boats are often very colourful. The *Julius Geirmundsson*, which I found in Hull docks, had a blue-painted hull, white superstructure and orange cladding around the upper deck. The stern was painted a reddish brown, and the superstructure aft was painted green and yellow.

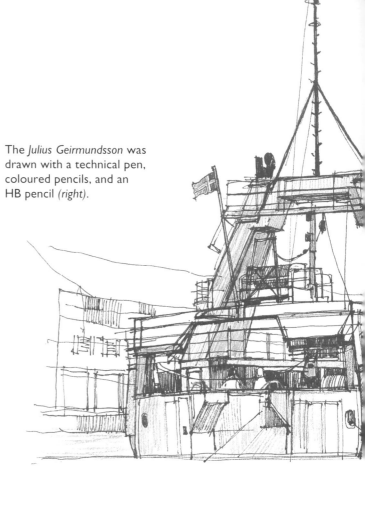

The *Julius Geirmundsson* was drawn with a technical pen, coloured pencils, and an HB pencil *(right)*.

A colourful group of three cargo boats at Port Penrhyn, Wales, drawn with pen and ink and felt-tips *(below)*. When faced with a multitude of masts, the addition of colour helped to sort out which boat was which. For me, the attraction of this scene lay in the gentle curves of the hulls offset by the dynamic diagonals of the masts and the solid, rectangular shapes of the cabins.

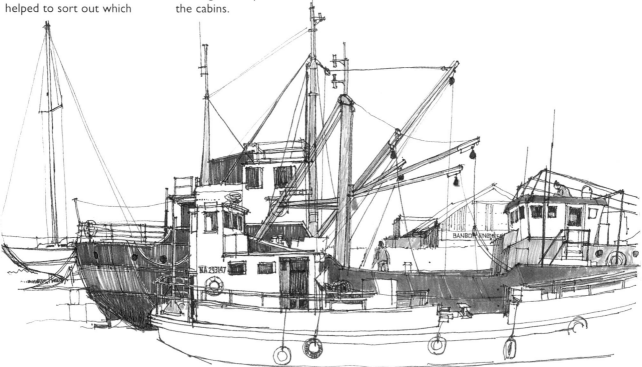

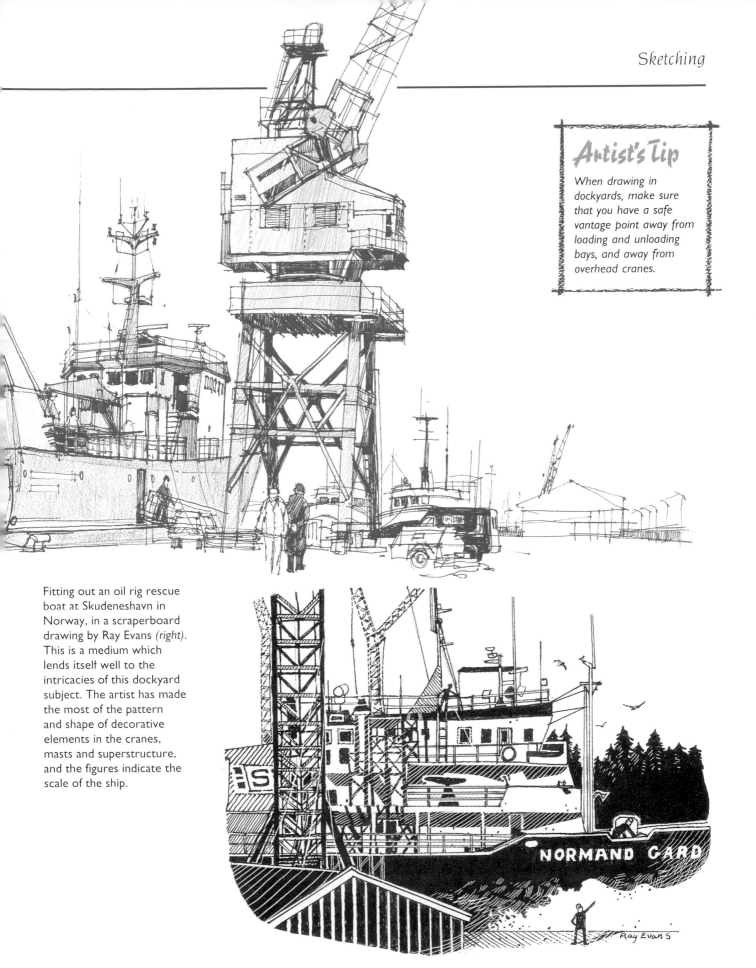

Artist's Tip

When drawing in
dockyards, make sure
that you have a safe
vantage point away from
loading and unloading
bays, and away from
overhead cranes.

Fitting out an oil rig rescue
boat at Skudeneshavn in
Norway, in a scraperboard
drawing by Ray Evans *(right)*.
This is a medium which
lends itself well to the
intricacies of this dockyard
subject. The artist has made
the most of the pattern
and shape of decorative
elements in the cranes,
masts and superstructure,
and the figures indicate the
scale of the ship.

NORMAND GARD

Ray Evans

Inland waters

Many marine subjects can be found on rivers, canals and lakes where the waters are often placid, even motionless, allowing you to depict the calm of moored boats.

Today many people holiday on the canals in narrow boats, and some are even used as floating homes. Narrow boats can make good subjects, especially those that are traditionally decorated in primary colours. I found these modern narrow boats being maintained at the Evesham Marina on the River Avon.

All the drawings on these two pages were made on mid-toned Ingres paper with conté pencil, watercolour, and touches of white pastel.

Opposing bows of narrow boats moored in winter isolation within the inner marina made a good composition *(below)*.

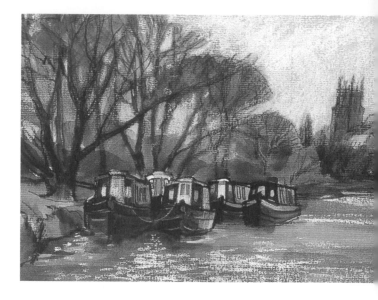

Boats moored to the riverbank *(above)*. The darks were put in first with watercolour. White pastel was dragged over the textured Ingres paper, allowing parts to show through, and finally some detail was added with conté pencil.

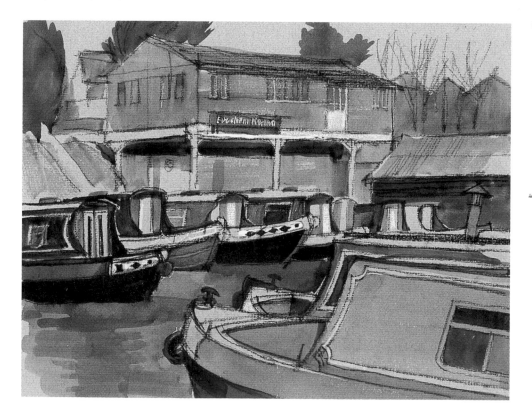

Artist's Tip

Travel light if walking a distance. Take a small folio for paper which can be used as a drawing board. Clip paper to it at each corner to keep control in a strong wind.

Another view from inside the marina *(opposite)*. Here you can see the 'Z'-shaped tiller and open cockpit which allows access to the cabin. Such details can provide strong design elements that can be incorporated into a painting – in fact, the zigzag shape of the tiller is already echoed in the overall shape of the boats as a whole.

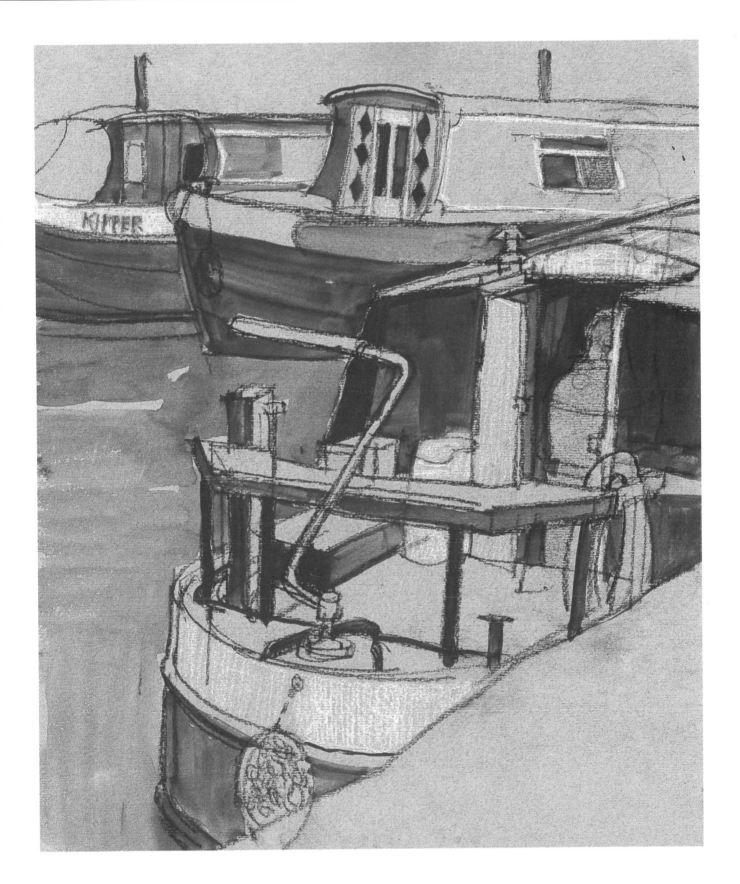

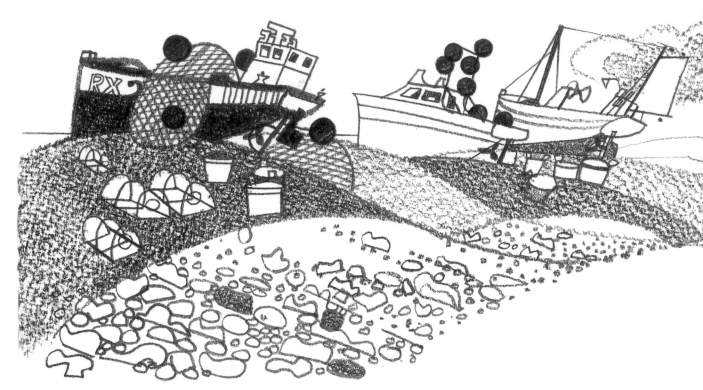

Seashore

In summer the seashore can be buzzing with boat activity – and also buzzing with lots of people who like to look over your shoulder while you sketch. I try to be unobtrusive, often sitting in the shade alongside a boat if possible.

In winter the seashore can be windswept, bleak and forbidding but, if you can brave the elements, then the lonely atmosphere, screeching seagulls, rolling breakers, and even the smell of seaweed can do much to inspire the artist in you.

You will find a rich fund of pictorial images, such as the tilted masts of a boat on shore at low tide seen against a background of distant cliffs. A feeling of space and distance can be emphasized by the incidental presence of figures in the distance.

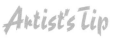

Artist's Tip

Using toned paper instead of white paper on a bright day can cut down the reflected glare of the sun.

A drawing by Ray Evans of Norwegian fishing boats pulled up onto the rocks in a creek near Skudenshavn (*left*), with a few seagulls circling overhead, and a pattern of flotsam and jetsam among the rocks.

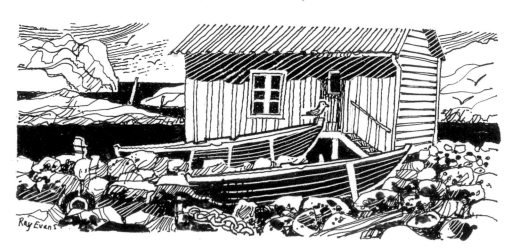

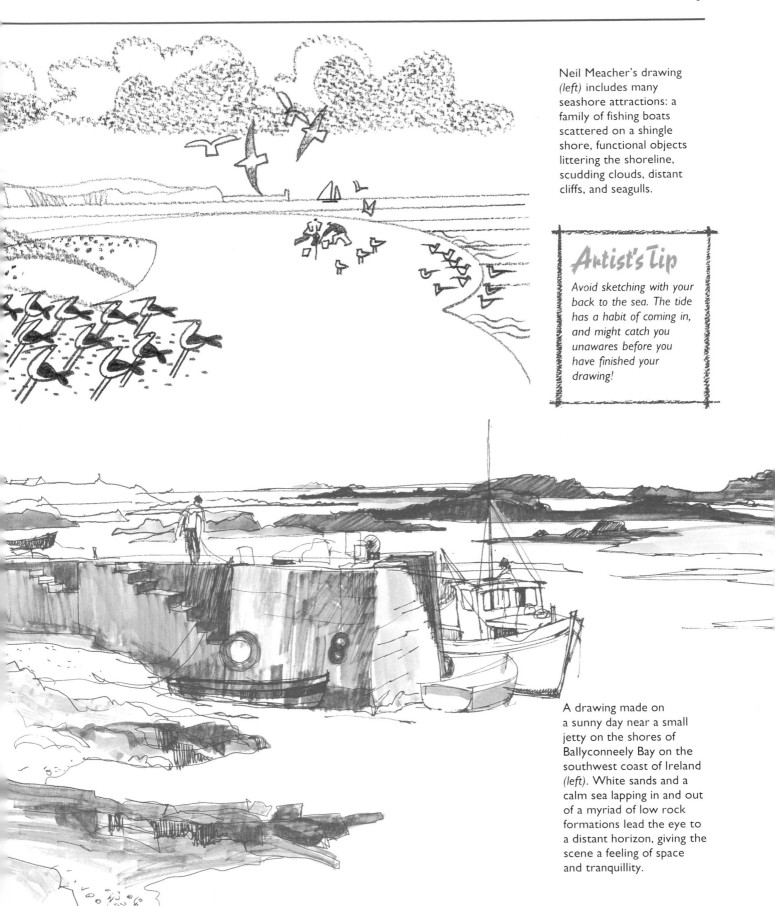

Neil Meacher's drawing *(left)* includes many seashore attractions: a family of fishing boats scattered on a shingle shore, functional objects littering the shoreline, scudding clouds, distant cliffs, and seagulls.

Artist's Tip

Avoid sketching with your back to the sea. The tide has a habit of coming in, and might catch you unawares before you have finished your drawing!

A drawing made on a sunny day near a small jetty on the shores of Ballyconneely Bay on the southwest coast of Ireland *(left)*. White sands and a calm sea lapping in and out of a myriad of low rock formations lead the eye to a distant horizon, giving the scene a feeling of space and tranquillity.

Working from Reference

It is sometimes necessary to work from references, rather than life, and these could be anything from a marine painting or a book illustration to a photograph you have taken yourself. Never let your drawing be dominated by a photograph, however. You are trying to create an illusion of space and three-dimensional form and a photograph is only two-dimensional.

How photographs can help
However, there are occasions when photographs are useful, particularly in recording moving objects, such as sailing boats at sea, breaking waves, or a boat that is about to put to sea before you have finished your drawing!

The camera can also come to our aid in recording a complicated subject that cannot be completed on time, or as an information back-up when undertaking commissions, such as the Belfast Harbour picture here. With only one day to make drawings and colour notes on site, additional photographs were useful reference, when creating the finished piece in the studio.

Try to use a photograph in your own way: adapt it, give it life, and perhaps reconsider the composition when developing your drawing. Defining tones can be difficult when you are using a colour photograph, so from this point of view black and white photographs are better.

A watercolour and pen-and-ink sketch of background details that might be used in the final drawing (left).

A pencil sketch of the ferry at the quayside (below).

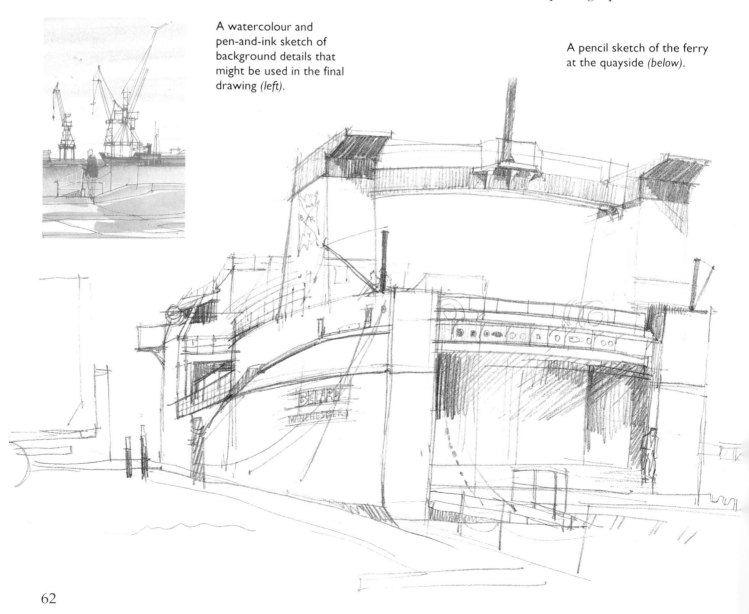

This photograph was useful in reminding me of colour and detail *(right)*.

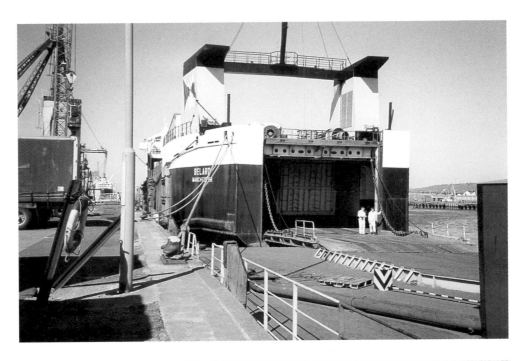

The final picture, done in watercolour and gouache *(below)*. Notice how the direction of light recorded in the pencil sketch and photograph has been altered here to give more definition to the superstructure, and how many of the details in the foreground have been omitted to simplify the composition.

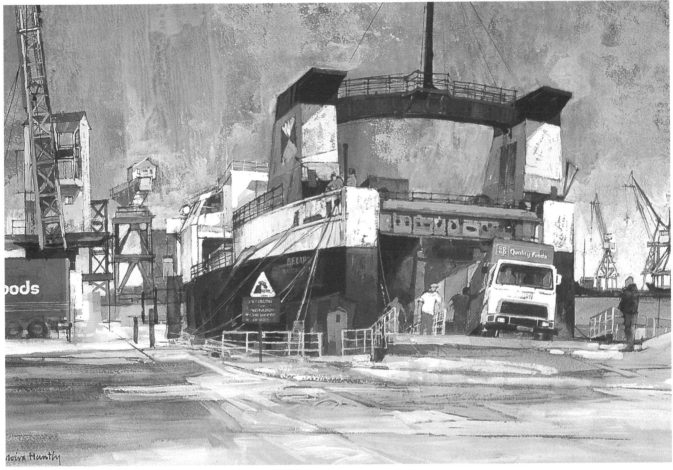

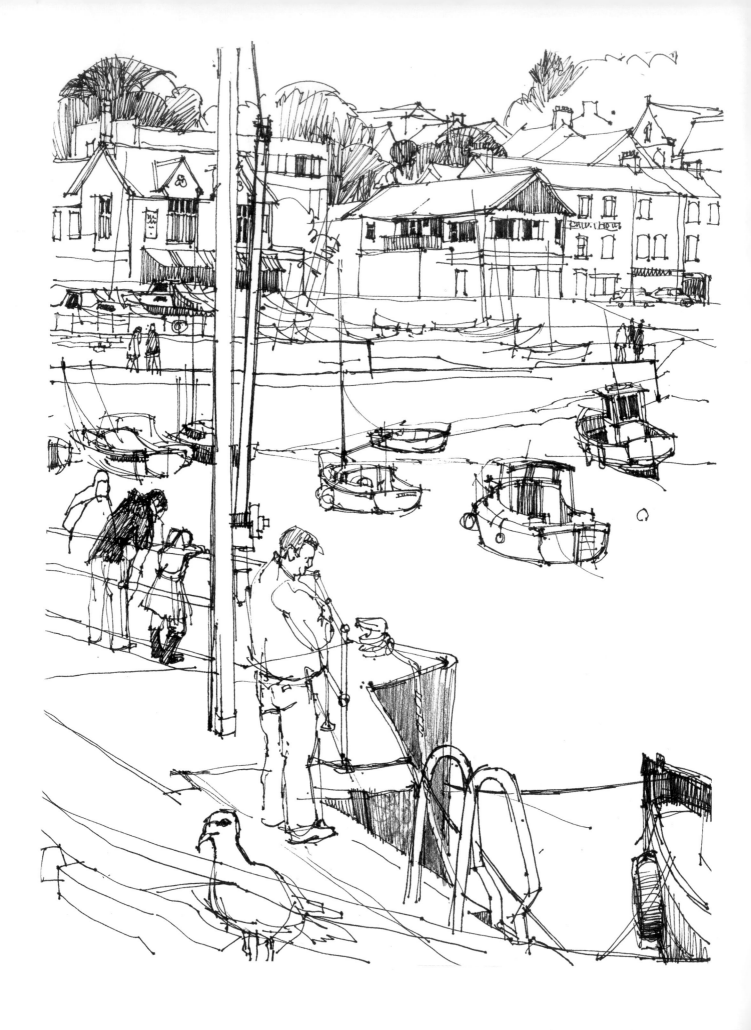